Understanding
Exposure

THE EXPANDED GUIDE

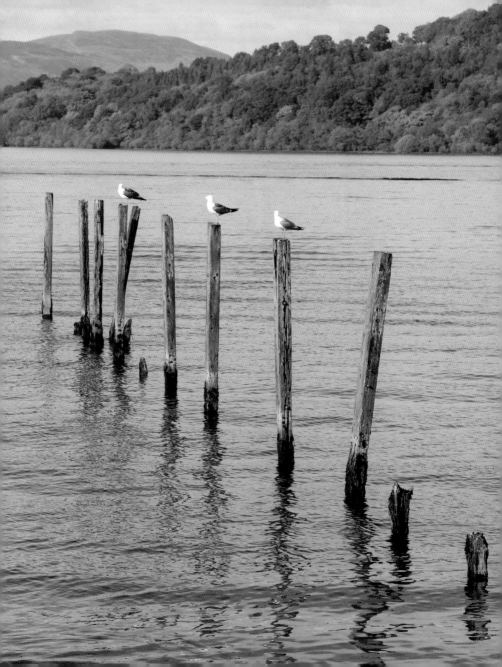

Understanding
Exposure

THE EXPANDED GUIDE

Andy Stansfield

AMMONITE
PRESS

First published 2011 by
Ammonite Press
an imprint of AE Publications Ltd
166 High Street, Lewes, East Sussex, BN7 1XU

Text © AE Publications Ltd, 2010
Illustrative photography © Andy Stansfield, 2010
Front cover © Mark Penny/Fotolia, 2010
© in the Work AE Publications Ltd, 2010

ISBN 978-1-906672-99-7

A catalogue record for this book is available from the British Library.

Editor: Chris Gatcum
Series Editor: Richard Wiles
Design: Fineline Studios

Typeset in Frutiger
Colour reproduction by GMC Reprographics
Printed and bound in China by Hing Yip Printing Co. Ltd

CONTENTS

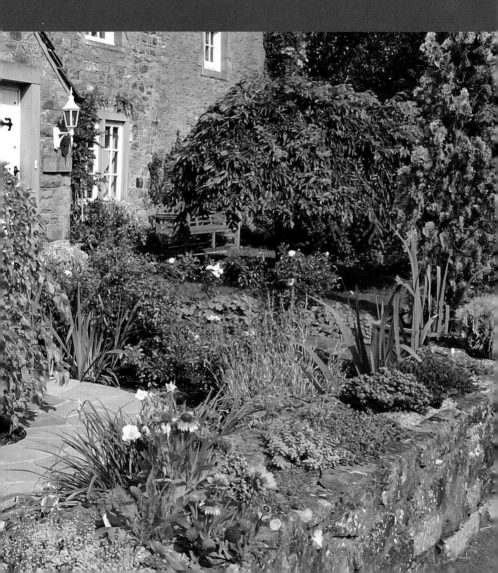

Exposure

Definition: The camera and lens settings that determine the amount and qualities of light falling on the medium used to record the image. Traditionally shutter speed, aperture, and ISO with film, but the digital age expands this list to include in-camera adjustments that determine how the exposure data is interpreted: color space, white balance, dynamic range, sharpness, noise, filter effects, and more.

Perhaps the first issue to clarify in this book is the difference between the terms "exposure" and "metering." Exposure is a term that describes the actual settings used to capture an image, whereas metering provides only a suggested group of settings that you are free to ignore, override, or adjust as you see fit. It is vital to remember that in-camera metering systems, which many of us rely on quite extensively, may have grown extremely sophisticated, but they are not absolutely perfect for every situation.

The second important point relates to which file format you use to record your images, provided your camera offers both RAW and JPEG options. If you want to print images directly from your memory card, for example, you will need to record images using the JPEG format and you will need to have exposed them with a fair degree of accuracy. However, if you are comfortable with adjusting images on your computer before printing (generally referred to as post-processing), you have a little more leeway with the exposure. This is especially true if you are recording your images as RAW files, as these allow you to adjust almost all of the

original camera settings during post-processing, including the exposure.

The three main settings at the heart of exposure are aperture, shutter speed, and

QUANTIFIABLE FACTORS
Exposure value
Color temperature
ISO setting
Aperture
Shutter speed
Sensor size
Focal length*

*Note
With so many different sensor sizes available today, references to focal length would be clumsy if every reference had to account for sensors with a crop factor of 1.3x, 1.5x, 1.6x, 1.7x, and so on. Consequently, all of the focal length references in this guide refer only to the focal length as used with a full-frame sensor (or 35mm film).

ISO. Virtually every camera offers at least one fully automatic mode in which the camera sets all three of these for you. Most will also provide a number of fully or largely automatic modes often referred to as "scene modes" that will also determine the aperture, shutter speed, and ISO automatically, but based on the subject matter of the image or the type of circumstances in which the photograph will be captured. Before we examine their relationship in greater detail, let's first look at these three settings individually.

Aperture

The word aperture means an opening through which something passes, and in this context we are talking about an opening within a camera's lens through which light passes (the mechanics of which are described more fully in Chapter 3).

The light waves project an image onto the film or sensor, with the size of the aperture controlling the amount of light that is allowed through. This obviously has an impact on the brightness of the resulting image.

If you peer into any lens from a camera that takes interchangeable lenses you will clearly see this opening, formed in the center of a number of overlapping blades. The shape of this can be (but usually isn't) a perfect circle.

When we talk about the aperture used for a particular photograph, we are really talking about the size of the opening and, in order to be precise, we refer to it numerically, as a fraction of the focal length. The number used is preceded by a lower-case letter f, sometimes italicized and followed by a slash; for example, f/8. The actual range of numbers used will be explained shortly.

SECONDARY FACTORS

On occasions, any of the following can have some impact on the choice of aperture, shutter speed, or ISO:

Light direction
Color space
White balance
Depth of field
Post-processing
Intended use
Final image size
Viewing distance

Tip

If you are eager to expand your skills quickly, and your camera has the option to record both RAW and JPEG images at the same time, you can adjust the RAW image in a variety of ways during post-processing and compare the results with the JPEG version, side by side. This can tell you quickly whether you need to adjust your metering technique. Later on, this approach can also help you to fine-tune the exposure parameters that your camera offers.

Shutter speed

The shutter speed refers to the amount of time that the light waves passing through the aperture are allowed to fall on the recording medium, be it film or the sensor in a digital camera. There are several types of shutter mechanism (descriptions of which would cloud the issue at this point), so at this stage it is only necessary to appreciate that the shutter offers another mechanism for controlling light, in this case the duration that light waves are allowed to form an image on the recording medium. This is always expressed as whole minutes, whole seconds, or a fraction of a second (1/500 sec., for example).

ISO setting

The ISO setting refers to the sensitivity to light of the recording medium and is expressed numerically; ISO 200, for example. One disadvantage of film is that a constant ISO has to be applied to every frame on the roll of film, whereas with digital cameras the ISO setting can be changed for individual photographs. The acronym ISO stands for International Organization for Standardization, the body responsible for setting regulations that all manufacturers must adhere to.

Stops

A stop is the term used by photographers to describe the doubling or halving of the light received by the recording medium. This means that the term can be used in conjunction with any of the three main settings concerning light: aperture, shutter speed, or ISO. Usually we refer to 1 stop faster, meaning a halving of the light received by the recording medium, or 1 stop slower, meaning twice as much light being received. (It is important to understand that the terms faster and slower in this context do not relate only to shutter speed.)

Summary

The easiest analogy to draw when it comes to the relationship between the aperture and shutter speed is that of cooking a meal in the oven: You can opt for two hours at 150° or one hour at 300° and the outcome will be largely the same. Think of these as being the shutter speed and aperture. Continuing this analogy,

	SLOWER								FASTER			
Whole-stop ISO settings	50 100 200 400 800 1600 3200 6400 12,800 25,600 51,200 102,400											
Whole-stop shutter speeds	1 sec. 1/2 1/4 1/8 1/15 1/30 1/60 1/125 1/250 1/500 1/1000 1/2000 1/4000 1/8000											
Whole-stop aperture settings	f/64 f/45 f/32 f/22 f/16 f/11 f/8 f/5.6 f/4 f/2.8 f/2 f/1.4 f/1											

APERTURE

At first glance, the numerical progression through the different aperture settings appears less obvious than the progression of shutter speeds or ISO settings, unless you see it expressed diagrammatically.

It is often this not-very-obvious numerical progression that causes beginners to go blank at the very sound of the word aperture. If you are one of these, don't worry. Simply try to remember f/4, f/8, and f/16 for now, and that f/16 is the smallest opening of these.

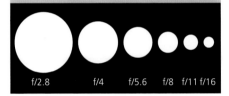

f/2.8 f/4 f/5.6 f/8 f/11 f/16

APERTURE, SHUTTER SPEED, AND ISO

This image was captured using an aperture of f/11 and a shutter speed of 1/500 sec. at ISO 200. In terms of exposure, and ignoring other issues such as depth of field, any of the following aperture and shutter speed combinations could have been used to generate the same outcome at ISO 200:

f/4 @ 1/4000 sec.	f/11 @ 1/500 sec.
f/5.6 @ 1/2000 sec.	f/16 @ 1/250 sec.
f/8 @ 1/1000 sec.	f/22 @ 1/125 sec.

Had ISO 400 been selected, the corresponding exposure would change by 1 stop, so could have been any of these combinations:

f/4 @ 1/8000 sec.	f/11 @ 1/1000 sec.
f/5.6 @ 1/4000 sec.	f/16 @ 1/500 sec.
f/8 @ 1/2000 sec.	f/22 @ 1/250 sec.

you have a third factor that can also affect the outcome—the height of the oven shelf. This equates to the ISO speed. OK, so my cooking skills fall a little short of any photographic expertise I may possess, but you get the idea: the key to exposure is getting the correct balance between these three variables.

A simple way of witnessing the relationship between the shutter speed and aperture is to set your camera to Program mode. If you shift the exposure, you will see that the camera scrolls through a variety of different combinations, each of which will give the same overall result at the selected ISO speed.

Tip

The so-called "sunny 16 rule" suggests that, in bright sunlight, an aperture of f/16 can be selected in combination with a shutter speed that is the reciprocal of the ISO setting; for example, 1/200 sec. at f/16 for an ISO setting of 200.

Camera modes

The technological rollercoaster that has hurtled through camera development at breakneck speed throughout the last decade should have made life easier. It did, for a while, but even inexpensive compact digital cameras now offer a huge range of settings options. There is much to explore, to learn, and to experiment with these days, but most of the technology can be broken down into several topics that are outlined here and explained in greater detail later in this guide.

Primary and secondary exposure

The terms *primary* and *secondary* exposure are not standard terminology, but they have been used here to separate the adjustments made in-camera at the time of shooting from post-capture corrections.

Primary exposure settings are the ones that you will use in-camera when you capture an image. They incorporate the main settings of ISO, aperture, shutter speed, exposure compensation, exposure bracketing, Highlight Tone Priority (Canon), and Active D-Lighting (Nikon) or Auto Lighting Optimizer (Canon), or similar settings from other manufacturers. They can also include anything else that affects the exposure, the dynamic range, or the color balance.

It is worth noting that after dialing in any adjustment to the dynamic range through settings that affect the balance between highlight and shadow areas (such as Active D-Lighting or Auto Lighting Optimizer), the aperture and shutter speed combination will sometimes need further adjustment before capturing an image.

Secondary exposure correction describes any exposure corrections made to an image after it has been captured. Essentially, secondary exposure corrections can take place either in-camera (a facility that is slowly becoming more widespread) or on the computer after downloading your captured images. At the present time, the vast majority of photographers are still limited to making secondary exposure corrections via a computer.

Post-processing is a term commonly used to describe post-capture adjustments, which may incorporate exposure adjustment in addition to other changes to an image that do not fall into the category of exposure; the post-capture application of digital filters, for example. The most important factor determining which secondary exposure corrections are available is whether you shoot JPEG or RAW files, with RAW files providing a greater range of options.

Full Auto

Full Auto—or *Intelligent Auto* on Panasonic cameras—is probably the shooting mode that is most commonly used by beginners, and it is likely to be one of several automatic modes on your camera. The term *Full* Auto has been used to differentiate this mode from other partially automatic modes such as Program, Aperture Priority, Shutter Priority, or any one of the various scene modes.

Set to Full Auto (commonly marked as A), the camera will make all your decisions for you

the camera will make all your decisions for you with regard to the aperture, shutter speed, and ISO. It is also likely to set the file quality (to JPEG) and a range of other options—almost everything except focus. It is usually the case that the user cannot override many, if any, of these settings, but Full Auto is still capable of delivering perfect images provided there aren't any awkward lighting challenges: the main thing you are giving up is control, not quality. Well-lit, evenly toned scenes should turn out fine. When they don't, it is time to start learning again.

Program

Program mode offers a little more control than Full Auto and is often the next step on the learning curve for beginners. In this mode, the camera's meter determines the exposure and suggests a combination of aperture and shutter speed. This pairing can be changed using what is sometimes referred to as *program shift*, but the overall exposure will remain the same. For example, if the camera suggests an exposure of 1/500 sec. at f/8 this can be changed to any equivalent exposure such as 1/1000 sec. at f/5.6, 1/250 sec. at f/11, and so on.

This allows the user to select a suitable aperture or shutter speed, while still making sure that the overall exposure renders a satisfactory result without the confusion of changing shooting modes. This kind of thinking is the precursor to experimenting with Aperture Priority or Shutter Priority.

A couple of years ago, Canon introduced a new shooting mode in the form of Creative

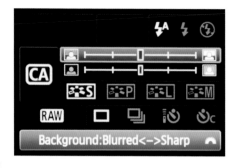

Auto, which is similar to Program but with a low-tech approach to the user interface. A new slider control is incorporated into the menu screen (shown above), which allows the user to make conscious decisions about how blurred or sharp the background needs to be. The slider is actually controlling the aperture (and therefore the depth of field), but without reference to any of the technical terminology. The shutter speed is set automatically.

Aperture Priority

When you want to have complete control over the aperture, this is the mode to use. For example, you may want to use a wide aperture for a very restricted depth of field, blurring the background behind the main subject. Alternatively, you may want to use a small aperture to provide a greater depth of field, so the foreground, middle distance, and far distance are all in focus. Having selected the aperture, the camera will determine an appropriate shutter speed according to the meter reading. The difference between this and the more automated modes is that the user retains control over a wider range of settings.

Shutter Priority

This works just like Aperture Priority, except that the photographer sets the desired shutter speed. This may be because you want a fast shutter speed to freeze movement in a fast-moving subject, or it could be that you want to deliberately blur the motion in an image by using a slow shutter speed, such as when photographing a waterfall. In both situations, the camera chooses the appropriate aperture.

Manual

In Manual mode the user has to set both the aperture and the shutter speed independently of one another. If the selected combination does not match the exposure reading suggested by the camera's meter, there will be a mechanism for indicating that overexposure or underexposure is likely. However, it is highly likely that the user has already determined that it is the meter reading that is inappropriate,

which is why the camera has been set to Manual mode in the first place: The camera isn't always correct, which is why you are reading this book, right? If you start reading this guide relying on Full Auto and finish it using Manual, then all my efforts will have been worthwhile.

Scene modes

This is the generic term used to describe a wide range of shooting modes that are geared toward specific shooting situations. There is a great deal of overlap between the different modes adopted by different camera manufacturers, but most will provide scene modes that include Portrait, Landscape, Sports, and Close up, for example.

The thinking behind these modes is that an inexperienced user will know what type of shot is desired—a landscape, which would require ample depth of field, for example. So the manufacturer ensures that an adequate aperture is selected automatically when the camera is switched to the Landscape scene mode.

The disadvantage of these modes is that, as with Full Auto, the majority of camera settings are determined automatically, with little scope for adjustment. They are helpful for the beginner, but they also take away any incentive to learn about taking control of all that the camera offers. Scene modes are also likely to record images as JPEGs, removing many post-processing options.

With a greater understanding of both exposure and the camera itself, it soon becomes obvious that just because a scene mode is labeled "Sports," that doesn't mean this mode isn't suitable for other subjects that demand a fast shutter speed.

Picture styles

For want of a better expression, I have used the term picture styles (note the lower case "p") to describe the facilities provided by Nikon (Picture Control), Canon (Picture Styles—note the capitals), and other manufacturers to control groups of parameters that affect the sharpness, contrast, and color characteristics of an image, on which there is more in Chapter 8.

Picture styles can usually be applied to either JPEG or RAW files, although to keep the style with a RAW image you will likely need to be using the manufacturer's own conversion software. If so, they can also be applied retrospectively to RAW files.

Although there are a number of different styles, most manufacturers include the same "basic" package: Standard, Natural, Vivid, Landscape, and Portrait. The differences between them will vary from manufacturer to manufacturer, but in general you should be wary of over-using any "vivid" setting—you may be better off using a less saturated mode in-camera and then increasing the color saturation during post-processing for greater control.

PICTURE STYLES

The top image was taken using Nikon's Standard Picture Control setting, while the lower photograph was taken using its Landscape Picture Control. As you can see from the background, Landscape picture styles tend to boost any green in an image, as well as any blue.

A Portrait picture style will generally offer a slightly warmer white balance overall, to improve skin tones. This may be combined with a slight reduction in sharpness to help soften wrinkles.

Focal length: 300mm, Aperture: f/16, Shutter speed: 1/500 sec., ISO: 640

Focal length: its impact on metering and exposure

Your choice of focal length will determine how much of the scene before you is captured in the image. In turn, this means that it may also determine the extent to which light or dark areas dominate the image, depending on the composition. However, it is important to note that while changing the focal length for a scene can affect the meter reading, it may not necessarily change the exposure that is required.

A longer focal length can make the subject more dominant in the frame (as demonstrated in the example below), which can impact on the exposure when your subject is especially light or dark. It is important that the main subject is correctly exposed.

In the images below, the castle looks almost identical in tone in both shots, but it received an exposure that was ⅔ stop darker in the second photograph, taken using a 22mm focal length.

This is because an identical exposure would have rendered the foreground too light, drawing the eye from the castle itself. This highlights one of the peculiarities of working with wide focal lengths for landscapes in particular: the more elements there are in an image, the more they need to integrate, in terms of exposure as well as composition.

Tip

Exposure issues when using wideangle focal lengths are almost always due to the metering being affected by areas of the image that are secondary to the main subject; sky in the background, water in the foreground, or large areas of sand in a beach scene, for example.

DUART CASTLE

Below Left:
Focal length: 116mm, Aperture: f/16, Shutter speed: 1/160 sec., ISO: 200

Below Right:
Focal length: 22mm, Aperture: f/16, Shutter speed: 1/250 sec., ISO: 200

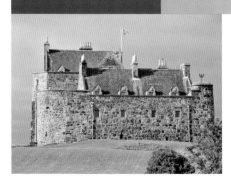

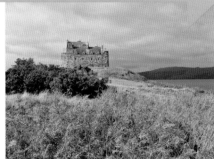

Viewpoint

Just as focal length can influence the metering suggested by your camera, so too can your camera position. In the examples below, the upper image provides a fairly straightforward situation for a camera's meter, but the lower image contains a greater amount of shadow area, which will cause the meter to suggest a greater exposure than is required.

Both images were captured at exactly the same exposure, by taking the exposure reading from the center of the frame and setting it manually for both shots. If you are using a zoom lens, you can zoom into the scene to obtain your exposure reading, then zoom out to recompose the shot, using the reading obtained to set the exposure manually.

MANUAL EXPOSURE
To ensure that both of these images received the same (correct) exposure, I zoomed into the stonework and took an exposure reading. Switching to Manual mode I set the aperture and shutter speed to match the exposure reading. This meant that the stonework was exposed identically in each shot, even though I moved the position of the camera to take these two photographs from different viewpoints.

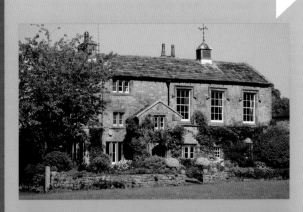

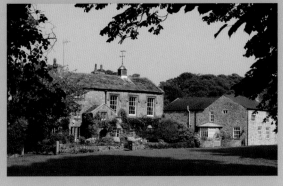

Focal length: 55mm,
Aperture: f/8, Shutter speed:
1/1000 sec., ISO: 200

Sense of purpose

Unless you know what you were trying to achieve, how can an image be deemed a success as opposed to a happy accident? For those who own a range of camera equipment, the sense of purpose begins before stepping out of the door—by deciding what equipment to carry. This might also include how that equipment should be carried, which will determine how readily accessible it is.

Other pre-shoot decisions might include the choice of focal length, shooting and focusing modes, file type and quality, or the use of filters, a tripod, a flash, or other accessories. In other words, you would enter a shooting situation already set up for the types of image that you have envisaged capturing. This is an important spin-off benefit from widening the range of equipment you own: the more you have, the wider the range of options.

Failing to learn the art of pre-empting what you are setting out to achieve will cause you a lot of heartache, as you will inevitably find yourself carrying everything but the kitchen sink, without any real idea how and when you will use the gear you have packed. Of course, there are times when it is necessary to take lots of equipment. At a sports event, for example, you will see photographers walking around with two or three camera body and lens combinations so they are ready for every eventuality. If they are professionals, this is a matter of necessity as they cannot afford to miss a newsworthy shot.

As you start to think about the situations in which you will be shooting, and the equipment you will need for them, you will naturally start to visualize individual images that you would like to capture. The reality of a shooting situation doesn't always match up to what you might have envisaged, but the fact that you have started to create possible images in your mind's eye beforehand will still be beneficial. You will have started to create, rather than react.

Strangely, the business of pre-visualizing images, or at least styles of image, also seems to flow naturally when photographers make a conscious decision to restrict their range of equipment. A classic scenario is when a photographer embarks on an extended trip that demands that only the minimum amount of gear can be carried—perhaps just one camera body and a single lens. Whereas most amateurs would probably opt for a wide-ranging zoom in this situation, hoping it will cope with all the situations which may arise, most professionals would select a fast, fixed focal length lens such as a 50mm f/1.2 or 35mm f/1.4, relying on experience and technique rather than a zoom to do the work for them.

If you want to examine the work of a great photographer who exemplified this sense of purpose, look no further than Norman Parkinson. Parkinson shot images for some of the great fashion magazines, such as *Vogue*, but it was his way of working that remains fascinating in this context. When he started out, he would be given four sheets of film for his plate camera and told to come back with three images worthy of a magazine cover. A success rate of 75% is something that many photographers would envy, but those three

shots would also be world-class—carefully crafted compositions with multiple elements to the subject matter. Most of Parkinson's work was in creating the shot and the lighting, and pressing the shutter release was just the final act. In fact, he was once quoted as saying that "the only thing that gets in the way of a really good photograph is the camera."

The critical moment

With experience comes the instinctive ability to know that a certain situation is going to yield a good image, as opposed to a competent, but relatively routine picture that could be captured by most photographers. These are the situations that a pro will milk for all they are worth.

The business of "milking the situation" involves what I refer to as "stalking" the subject—capturing it from a variety of angles, until one that is just perfect presents itself.

Yes, sometimes it is obvious from the start, and sometimes there is enough time to weigh up the options before shooting, especially if you have full control over the subject and lighting

> **Tip**
> Using continuous shooting mode isn't the sole answer to capturing the critical moment. If shooting tennis, for example, a ball traveling at 70mph will cover 34 yards in a single second, so the odds of getting the ball in shot are against you.

such as in a studio. But sometimes you just have to get stuck in straight away.

A really good photo is like a diamond, with many different facets that I refer to as "elements." The combination of these can sometimes be a matter of constant change, millisecond by millisecond, faster than we can react. One image in a sequence can sometimes draw these together better than those in the rest of the sequence.

An extension of this is capturing that often elusive "decisive moment." This means that neither one nanosecond before, nor one nanosecond afterward, will do; both would miss the exact point in time at which the image is at its most powerful.

This is particularly relevant to news and reportage photography, but it can also apply to situations that may be thought of as requiring a decreased sense of urgency, such as landscape photography. When the light is changing by the second, capturing the decisive moment is every bit as important, and in such circumstances there is rarely enough time to ponder which metering mode to use or how to compensate for awkward lighting situations. Consequently a pro will have already perceived that a shot is imminent, and that a scenario is unfolding, and their camera will be set up ready to pounce.

This is one reason why many professionals will habitually use manual exposure, setting it according to the prevailing light so they are not subject to the uncertainty of in-camera metering. This is especially important if shooting JPEGs that need to be wired instantly.

CHAFFINCH

Your own garden can yield spectacular images, such as this chaffinch about to land on a bird feeder. An elderly manual focus lens was pre-focused on the bird feeder and the camera was triggered wirelessly from a distance as the bird came in to land.

Focal length: 600mm, Aperture: f/5.6, Shutter speed: 1/4000 sec., ISO: 11,400

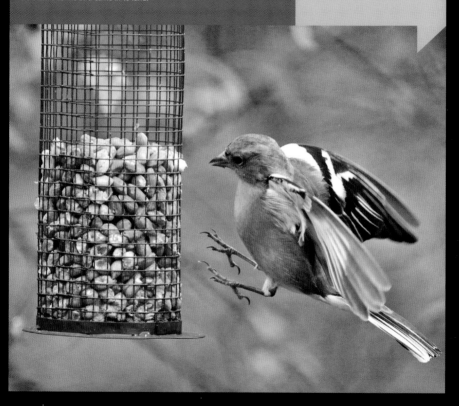

What went wrong?

Here we examine several images that display commonly encountered problems.

Overexposure

ASSESSMENT
This image is clearly too bright overall, easily seen from the green fields and the sky. This excessive brightness is known as overexposure—too much light has been recorded.

Focal length: 106mm,
Aperture: f/8, Shutter speed:
1/200 sec., ISO: 200

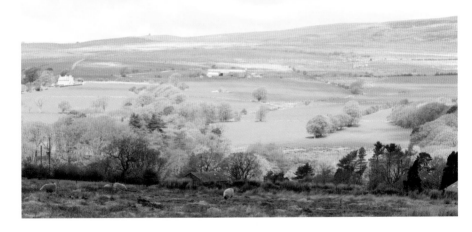

Solution

Memorize the "sunny 16" rule, which states that in bright sunshine the exposure will be the reciprocal of the ISO setting at f/16. In this instance, the exposure would be 1/200 sec. at f/16 at ISO 200. However, the sunlight was patchy and thin, so one additional stop would have been required. This would make the exposure 1/200 sec. at f/11, so the settings used (1/200 sec. at f/8) were 1 stop too much, allowing twice as much light to reach the sensor.

Alternative solution

If you are uncertain of the likely exposure needed, use auto exposure bracketing.

RESCUE THE ORIGINAL IMAGE

Enough detail was recorded in the sky for this image to be "rescued" during post-processing. This was simply a matter of adjusting the brightness. Sometimes it is also necessary to make additional adjustments to contrast, shadow and highlight controls, levels, or color.

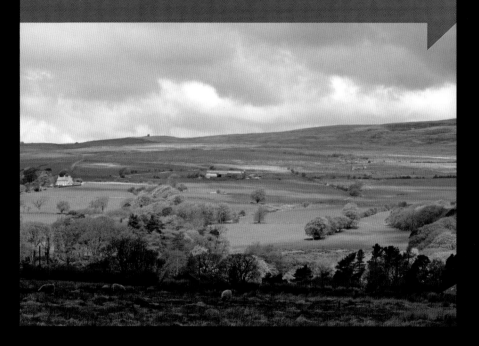

Underexposure

ASSESSMENT
This image is clearly too dark overall, which is easily seen in the grass and the sky. This is called underexposure, as not enough light has been recorded by the exposure.

Focal length: 280mm, Aperture: f/11, Shutter speed: 1/800 sec., ISO: 200

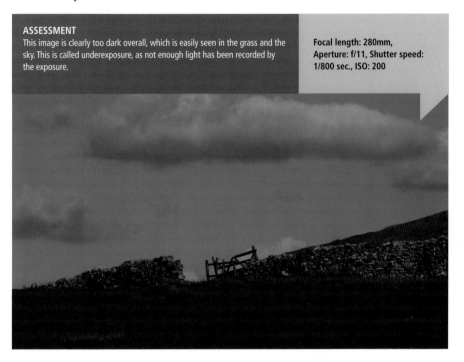

Solution

As with the previous example, knowledge of the "sunny 16" rule would have helped. The subject was evenly and brightly lit, so no adjustment to the rule would have been necessary. With a setting of ISO 200, an exposure of 1/200 sec. at f/16 would have been required. With f/11 selected instead, as was the case, this would have meant that a shutter speed of 1/400 sec. would have been suitable. A glance at the meter reading—1/800 sec. at f/11—would have signalled probable underexposure.

Alternative solution

Use the camera's auto exposure bracketing or exposure compensation functions. Tilt the camera down to meter from the grass (which is often a good reference point as a midtone) and use auto exposure lock—a facility that is present on almost all cameras—before shooting.

RESCUE THE ORIGINAL IMAGE
A simple adjustment to the brightness during post-processing is sufficient in this example.

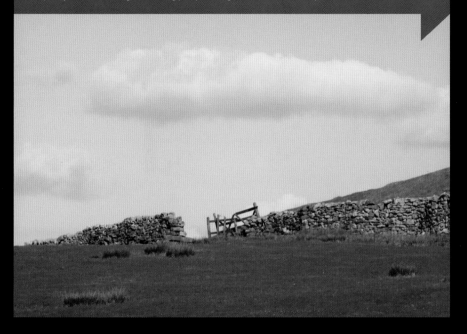

Too little contrast

ASSESSMENT
In this shot, the large area of sky dictates the meter reading leading to slight underexposure, but the image lacks contrast and the relatively small areas of color lack punch. Nevertheless, the scene has potential.

Focal length: 70mm, Aperture: f/4
Shutter speed: 1/2500 sec.,
ISO: 200

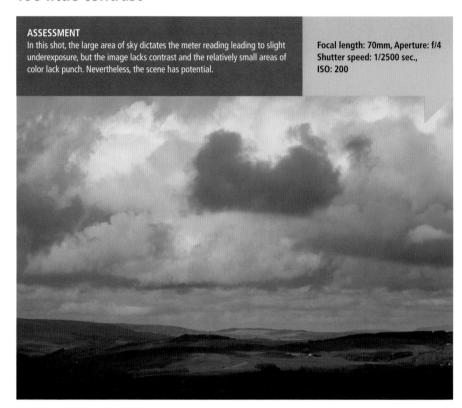

Solution

In this instance a sweeping vista was required that portrayed the fickle weather of the region, so I wanted to retain the large area of interesting cloud formations. Shot with a Canon camera, the final RAW image was captured using the Landscape Picture Style, which boosted the green of the fields and the small amount of blue sky along the top of the frame.

The saturation and contrast parameters were also increased more than would usually be the case. During post-processing in Digital Photo Professional (Canon's own software) the highlight and shadow slider controls were adjusted to finalize the balance across the range of tones; the same highlight/shadow adjustments can also be tweaked in Photoshop.

wait until a greater area of the landscape is lit by the intermittent sunlight and/or be more selective by zooming in on a portion of the scene that has more color and contrast to start with.

Rotating the camera 90° to vertical ("portrait") format would have allowed me to concentrate on the lit fields and greatest area of cloud contrast at the center of the scene.

RESCUE THE ORIGINAL IMAGE

The great advantage of shooting RAW files is clearly illustrated in these two examples because all of the parameter adjustments that would have formed an in-camera solution could be replicated during post-processing. Had the initial shot been captured as a JPEG, it would still have been possible to adjust the brightness, contrast, and color saturation to achieve an improved result.

Too much foreground

ASSESSMENT
One of the most common problems associated with wideangle focal lengths is the extra expanse of foreground or sky, or both. In this case, the large area of shadow in the bottom left corner exacerbates the problem.

Focal length: 17mm,
Aperture: f/5.6, Shutter speed:
1/320 sec., ISO: 200

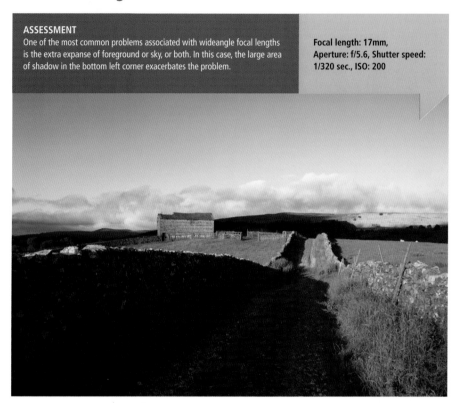

Solution

The original image was re-shot using a longer focal length (see opposite), although this meant the composition had to change and a smaller aperture was needed to keep the nearest section of the wall in focus. The sunlight on the distant hills was also lost between shots—this is the sort of detail that easily goes unnoticed once the initial attraction of the subject has drawn you to it, but which can help produce a stronger image.

Alternative solution

With all wideangle lenses, the answer is almost always to move closer. However, the section of track covered by shadow was sloping downhill so this would create other issues, such as the distant ridge on the left disappearing from view.

RESCUE THE ORIGINAL IMAGE

Although I re-composed the image using a longer focal length, the same effect could be achieved by cropping the original photograph during post-processing. All sorts of possibilities in terms of cropping using the more popular image ratios are available, and it would also make a nice panoramic shot.

CHAPTER 2 LIGHT

Light

First coined in 1839, the word *photography* is derived from a combination of two Greek words that roughly translate as "drawing with light." So it is clear that without light we would effectively be reduced to capturing images of a black cat at night.

FACTORS
Exposure value
Color temperature
Direction of light
Ambient light
Artificial light
Reflected metering
Incident metering

In some situations, such as when using flash or in a studio, we can exercise a lot of control over the light used to illuminate the subject. However, outdoors we are subject to the changeable nature of the weather, so it is often necessary to exercise a great deal of patience before the light we desire is prevalent. At the same time, though, these varying conditions provide us with lots of opportunities to capture our chosen subject in a number of different ways.

Consider the images opposite, which were taken moments apart. This top photograph relies on shape and an interesting sky, whereas the lower picture gives a greater feeling of being close to nature, providing additional information about the isolated tree and the moorland on which it thrives. The light changes everything.

Types of meter and metering

A lightmeter is simply a tool that measures the quantity of light falling on it (known as an incident reading), or the amount of light reflected by the subject (a reflected reading). In-camera metering makes use of reflected light readings, which means they are more likely to be fooled by overly bright or overly dark surfaces in the scene.

How helpful a meter reading is depends on how you, or your camera, interpret the result. Any light-meter reading—from a built-in multizone evaluative system to that of a 1° spot meter—provides a recommended shutter speed and aperture (for a given ISO) that would give the correct exposure for an 18% gray card. This is the mid-point between the brightest highlights and the deepest shadows that can be recorded.

With in-camera metering, the extent of the area to be metered is determined by the focal length of the lens in combination with the metering pattern you have selected. The camera's lightmeter "sees" the scene as

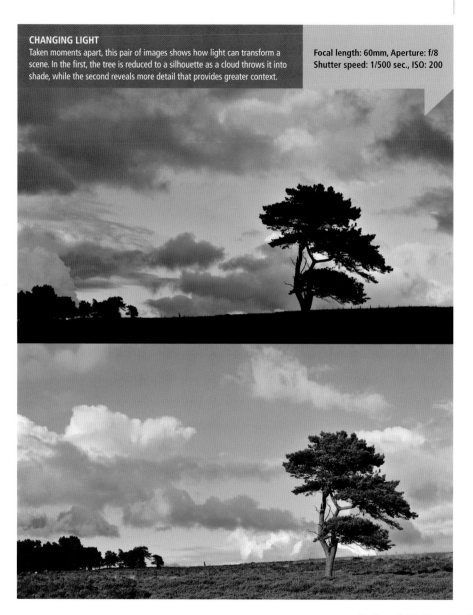

CHANGING LIGHT
Taken moments apart, this pair of images shows how light can transform a scene. In the first, the tree is reduced to a silhouette as a cloud throws it into shade, while the second reveals more detail that provides greater context.

Focal length: 60mm, Aperture: f/8
Shutter speed: 1/500 sec., ISO: 200

COLOR
The human eye (or, more accurately, the mind) tends to be influenced by color. We would be inclined to see the foliage as being "brighter," but when the image is converted to grayscale we can see it is almost equal in tone to the wall.

Focal length: 40mm, Aperture: f/16, Shutter speed: 1/30 sec., ISO: 200

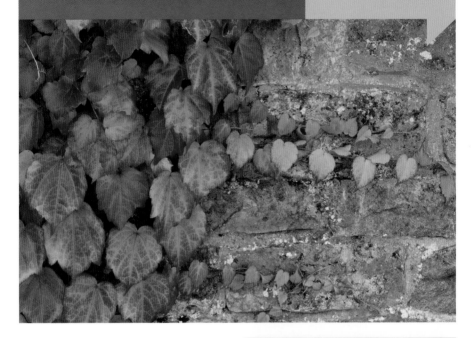

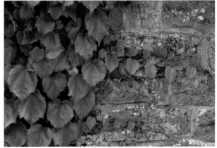

tones of gray and takes the exposure reading, suggesting an exposure that would give an "average" overall tone of 18% gray. The photographer can then adjust the suggested reading to account for highlight and shadow preferences if this is not done automatically by the camera itself; increasing the exposure to produce an overall lighter result, or reducing the exposure for a darker image.

Reflected light readings

All in-camera metering systems measure reflected light—that is the light reflected back from the subject toward the camera. This makes the metering system prone to error when faced with certain scenarios: large areas of highly-reflective substances such as glass or water, large areas of inherently bright subject matter such as sand or sky, and large areas of shadow or dark matter. All of these can fool a metering system that relies on averaging readings across the whole frame, although the term "error" above is really a misnomer—the meter is simply doing what it was designed to do.

One way in which we can combat these limitations is to narrow down the metering area, which is where partial, centerweighted, and spot-metering patterns come into play. But, used incorrectly, these metering systems can provide a suggested exposure that is even more inappropriate than using a matrix metering system to assess the whole scene. If you use spot metering and the area of the "spot" falls on a particularly bright or dark part of the subject, for example, the result is likely to be no better.

One significant advantage of in-camera metering when it uses a through-the-lens (TTL) system is that it automatically takes into account the effects of filters or the loss of light caused by using close-up accessories. TTL flash metering in particular makes life much easier, especially when using multiple flash units.

The key to obtaining the correct exposure using a reflected light reading lies in the choice of which part of the subject to meter and, as

with many things in photography, practice makes perfect. Most beginners find it hard to select a suitable midtone and are often fooled by bright colors, but there is an alternative: meter the darkest and brightest parts of the scene and then average the two readings. Alternatively, select what you think is the midtone, but bracket your exposures so you have a number of options to choose from.

Incident light readings

Compared to reflected light readings, incident readings are much easier to obtain. Using a handheld lightmeter with its translucent hemisphere in place, simply turn to face the light falling on the subject and take the meter reading. If it is possible to do so, position yourself close to the subject to do this.

An incident reading may still require some adjustment to allow for highlight or shadow detail but, in general, it is more likely to be accurate than a reflected light reading as it is measuring the light falling on the subject, rather than the light being reflected from it.

Camera metering

In-camera meter readings are usually given in whole stops, ½ stops, or ⅓ stops. Handheld meters may provide smaller increments than this, possibly as small as ¹⁄₁₀ stop.

With ambient light, some of the more sophisticated metering systems allow you to take multiple readings that are then averaged out automatically, or can be used by the photographer to determine a suitable mid-point for the exposure.

One feature that you will probably not see on a camera meter, but will in a handheld lightmeter, is an EV scale. This stands for Exposure Value and is a scale that applies to all combinations of aperture and shutter speed, using increments equal to 1 stop. So f/8 at 1/500 sec. will have exactly the same exposure value as f/5.6 at 1/1000 sec. (actually EV 15).

If you check the specifications for your camera it will almost certainly tell you the EV range across which its meter will perform accurately, typically EV 1–20, as well as the range within which the autofocus will work, typically EV -0.5–18. For reference, EV 0 corresponds to an exposure of 1 second at f/1, while EV 21 corresponds to an exposure of 1/4000 sec. at f/22.

Your camera's specification table will also show exposure compensation as being available using exposure values (for example ±3 EV). This means you can use the exposure compensation feature to over- or underexpose by as much as 3 stops from the metered reading, with 1 EV being the same as 1 stop.

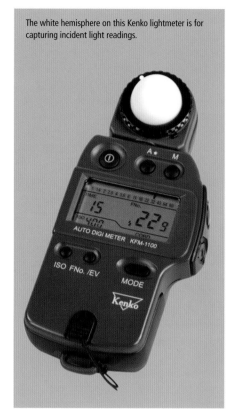

The white hemisphere on this Kenko lightmeter is for capturing incident light readings.

Handheld lightmeters

In principle, a handheld lightmeter functions in just the same way as the meter in your camera, but each has its advantages. A built-in meter can tie in with other functions on the camera, leading to developments such as Canon's iFCL dual-layer metering sensor that incorporates focus, color, and luminance information in its analysis of the scene.

On the other hand, when the camera is on a tripod, a handheld meter is much more flexible when taking incident light readings and close-up or spot readings.

Some meters are designed specifically for use with flash, but there are also meters that can be used with both ambient light and flash. Flash metering can be wired or cordless, and the meter may offer the facility to cope with multiple flash exposures.

Reciprocity failure

When exploring different sources in your bid to improve your understanding of exposure, you may come across the term *reciprocity failure*. This was something that landscape photographers working in low light needed to understand as it was a crucial factor when shooting long exposures, by which I mean exposures lasting several seconds or more. However, it only applies when shooting film and will not be a concern if you shoot digitally.

Reciprocity refers to the inverse relationship between light intensity and its duration. For example, twice as much light will require half the exposure. However, the chemically triggered sensitivity of film decreases when long exposures are applied in low-light conditions, especially when exposures run into minutes, such as when capturing scenes by moonlight. As a result, the exposure suggested by a lightmeter or in-camera meter needs to

IN-CAMERA VERSUS HANDHELD METERS
Most in-camera meters would struggle with this scene, where there are large areas of predominantly dark tones. Using a handheld lightmeter to take an incident light reading would prove more accurate in this low-light situation.

Focal length: 300mm, Aperture: f/5.6, Shutter speed: 1/1000 sec., ISO: 200

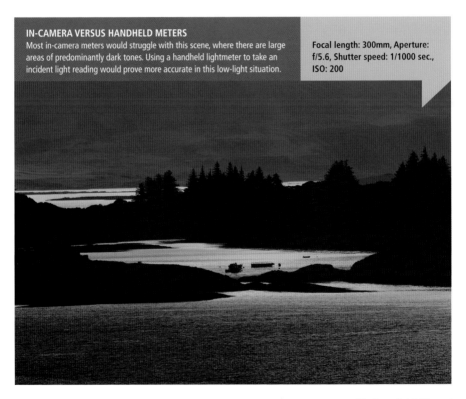

be increased considerably, which is why the term reciprocity failure is used. This might be an increase of 50%, or may extend to several times the suggested exposure.

As modern digital cameras are capable of functioning accurately down to light levels of around EV 0, the digital photographer no longer needs to worry about this issue, ensuring powerful images first time round. However, some manipulation of the color and tone in post-processing may be necessary to increase the sense of drama.

Color, color temperature, and white balance

While these settings are quite separate from those that dictate exposure, they are equally important to the final image and are all affected by inappropriate exposure. Overexposure weakens color saturation, especially in the highlights, while underexposure reduces shadow detail that includes color information. An aspect of digital photography that causes frequent concern is the incorrect rendition of blue skies due to incorrect exposure and/or contrast settings—sometimes it is necessary to reduce cyan levels in editing software such as Photoshop. The hardest images to correct are those taken with very wide focal lengths when a panoramic sweep of sky will be rendered in a range of blue tones.

Light has its own color, measured in degrees Kelvin (K). It can be warm in color, as at sunrise or sunset, or cool. This also applies to artificial light sources such as flash, household lamps, or fluorescent tubes. Most cameras provide

settings to match a wide range of light sources, such as those mentioned above, as well as different lighting situations such as sunny, cloudy, or shade.

The one color that will change predictably with shifts in color temperature is white, which is why the color settings on digital cameras invariably use the term "white balance." When a higher color temperature setting is used than is required for the prevailing lighting conditions, for example, white will not appear as pure white but as a very weak, warm shade.

If you want a scene to be registered with "normal" colors, you need to set an appropriate white balance: if it is cloudy, set the white balance to cloudy. This tells the camera to compensate for the "abnormal" mix of red, blue, and green light compared to "normal," which is assumed to be sunlight at midday (a color temperature of around 5500K). A higher color temperature than this will make the image appear cool (more blue), while a lower temperature will produce an overly warm (more orange) picture.

Normal color rendition, however, isn't always what we want because it can reduce the sense of atmosphere. So you can also choose to deliberately set a warmer or cooler white balance in order to achieve a desired effect. This works best when the desired color is already present: a weak sunset sky can be boosted by setting a higher color temperature than would normally be used, especially if a little extra saturation is also dialled in.

Many cameras also permit the setting of a custom white balance. Following the custom

white balance setting instructions for your particular camera, this involves shooting a plain white (or 18% gray) subject, such as a piece of card, under exactly the same lighting conditions as you will use to capture your intended scene. This image can then be used as a reference by the camera to calculate the precise white balance needed for the current lighting situation. This works well when the lighting is constant, but less well outdoors when the light is changing constantly.

Instead of photographing a white card, there is an increasing number of white balance accessories that fit directly over the lens. Some of these clip to the front of the lens like a lens cap, while others screw in like a filter, but both types will allow you to capture an "image" that can be used to set the white balance, often by simply aiming your camera at a brightly lit surface (ideally white), or a bright area in a scene such as the sky.

DAYLIGHT
This image was captured during the middle of the day using a Daylight white balance setting of 5200K. Overleaf are examples of the same picture taken at different color temperature settings.

Focal length: 35mm, Aperture: f/16, Shutter speed: 1/250 sec., ISO: 1600

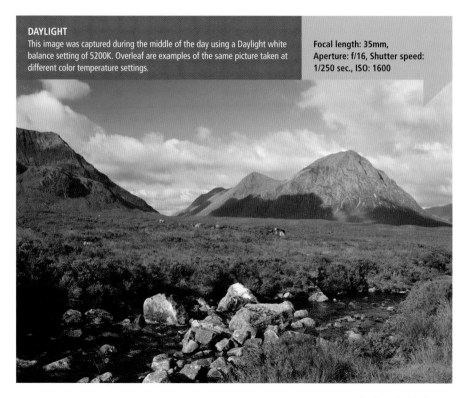

TUNGSTEN/INCANDESCENT
3000K

This would be the level of adjustment needed to counteract the distinct orange/yellow tones cast by ordinary domestic lighting.

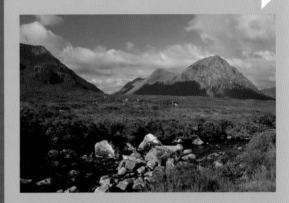

WHITE FLUORESCENT
4200K

This would be the setting used for white fluorescent lighting.

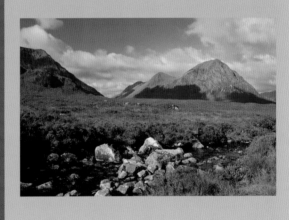

If you used any of the above settings with a normal daylight image, as shown on the previous page, the images you see here are what you would actually get. Note that adjustments at the lower end of the color temperature scale are more dramatic than the more subtle shifts at the warmer and higher end of the scale.

CLOUDY
7000K

Cloudy scenes typically need the white balance to be set at 6000–7000K to compensate for their slightly blue tint.

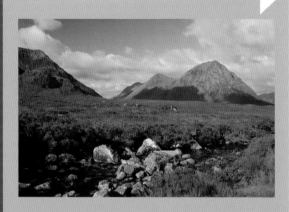

9000K

This lies between the Shade setting (around 8000K) and the highest setting (usually 10,000K) found on most DSLR cameras.

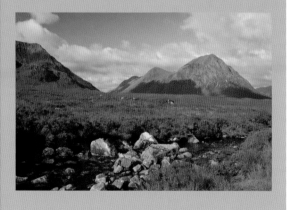

Tip

The best way to learn about color temperature is to shoot a few RAW images (as these permit the greatest manipulation) and "play" with them in RAW conversion software that allows a specific color temperature (in degrees Kelvin) to be set.

Composition

The way in which you decide to frame your subject can sometimes have an impact on the exposure. This usually depends on four things: the balance between the subject and the background in terms of area, how dark or bright the background is, the positioning of the main subject within the frame, and the metering mode selected.

As we're looking at composition in relation to exposure, this is also a good opportunity to give a few general hints on composing images. We can roll all these issues into one by looking at a single image, in this case the photograph below of a barn owl.

One of the things most beginners are guilty of is placing the main subject in the center of the frame, often square on to the camera. This produces a very static feel to an image.

Here, I've captured this owl side-on, but with its head turned toward the shooting position. This includes more of the bird's attractive darker plumage, but also the important diagonal line of its back running from the bottom right corner.

Diagonals in an image always provide a sense of dynamism, and intersecting diagonals can be used to direct the eye and provide points of special interest. It is also worth remembering that it is not just the visible line of the diagonal

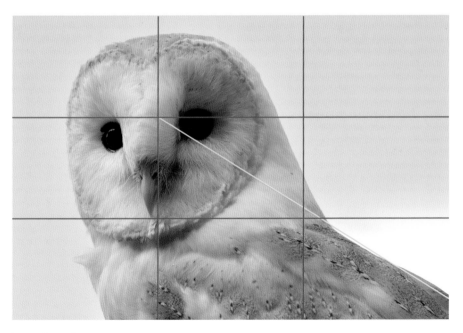

INGLEBOROUGH AT DAWN
As red grouse break the dawn silence with their alarm calls, this mountain emerges from the gloom.

Focal length: 116mm, Aperture: f/5.6, Shutter speed: 1/250 sec., ISO: 1600

that is important, but also the continuation of it, as shown by the yellow line, which leads the eye directly to the most vital part of the image.

When the image is divided into thirds you can see how the most distinctive features of the owl—the eyes and beak—are placed on the intersection of the thirds lines, which is a classic compositional technique.

In terms of exposure, there isn't a great deal of difference in tone between the subject and the background in this example, but the bottom-right corner is important because that

is where the difference is at its greatest; the contrast briefly draws the eye, which is then immediately directed back to the face by the diagonal. Because I was shooting a pale subject against the sky, a meter reading had already been taken from a midtone area in the same direction as the subject and Manual exposure mode had been selected.

Mood

While the mood you are in may affect your choice of subject and its treatment, the more important relationship is between the image and its viewer. Think of it as the "oooh" factor: if the viewer's first reaction is along these lines, you know you have captured something special.

Sunrise and sunset

A good place to start taking mood photographs, or rather a good time to start, is at sunrise or sunset. At both ends of the day, there is the opportunity to witness and capture spectacular skies. However, don't rely on the sky alone for your image, as this will mean you have just one element in the picture. The more elements an image has, the stronger it will be.

Instead, look for interesting foreground details or a major land feature that will make an attractive silhouette. At the right time of the year, early morning mist may form in valleys and add an ethereal touch.

Getting good color in the sky is simply a matter of metering: take a reading from the sky as this will establish it as the midtone. If the sun

LOCH NA KEAL
Dusk brings both blue and red tones to the sky, but the impact is doubled by their reflection in this Scottish loch.

Focal length: 20mm, Aperture: f/8, Shutter speed: 1/250 sec., ISO: 1250

is to be included, still take a reading from the sky, but choose an area away from the sun and its immediate glare.

Tranquility

For restful images, use a horizontal format and softer colors—diffuse light will provide better illumination than bright sunshine. Still water is always restful, but moving water can be dramatic unless you use a slow shutter speed to blur the water for a gentle mood. Set a low ISO and a wide aperture to increase the shutter speed, aiming for an exposure of 1/2 sec. or longer. If there is too much light, consider using a neutral density (ND) or polarizing filter to decrease the amount of light coming through the lens.

Reflections

Water and its reflections can be a great aid to enhancing moody lighting. Don't be afraid to allow subject matter to form silhouettes, provided the shapes formed are interesting.

MOUNTAIN STREAM
A low ISO, coupled with a small aperture setting, will help you get a suitably slow shutter speed for recording blurred water, but if it is very bright you may also need to consider using a neutral density filter as well.

Focal length: 35mm, Aperture: f/22, Shutter speed: 1/2 sec., ISO: 100

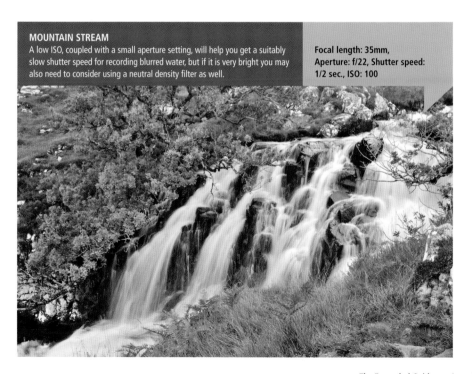

IN-CAMERA METERING MODES

EVALUATIVE OR MATRIX METERING

This system usually meters the entire frame, which is sub-divided into a number of zones. This pattern is capable of coping with a wide range of lighting situations, including backlighting. Canon's recently introduced 63-zone system also incorporates focus distance and luminance information in its analysis.

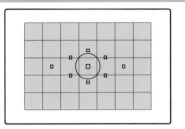

CENTERWEIGHTED AVERAGE METERING

This metering pattern averages readings from the whole frame, but gives added bias to the center, based on the assumption that this is where the subject will be.

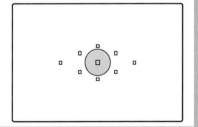

PARTIAL METERING

This system takes readings from a tightly defined area at the center of the frame, usually around 10% of the whole area. It is especially useful when the background is significantly brighter than the subject. It can also be used, in effect, as a spot meter with a larger-than-normal "spot."

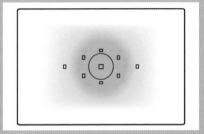

SPOT METERING

Similar to partial metering, a spotmeter reading makes use of an even smaller area at the center of the frame, somewhere in the region of 2.5% of the viewfinder area. It can be used to take readings from small, but important, areas of the subject in order to determine the average tone. Spot metering can sometimes be linked to a specific AF point for even greater versatility.

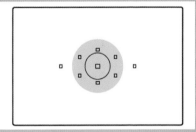

How metering affects exposure

The important difference between the different metering modes is the area across which light values are measured. The illustrations shown on the opposite page give a clear indication of these.

However, as with all matters pertaining to exposure, there is often a trade-off. The evaluative or matrix approach to metering will usually give an acceptable result across the entire frame, but key parts of the image may not be exposed exactly as you would wish.

Conversely, spot metering can give you a very precise exposure reading for a vital part of the image, but the rest of the image could be under- or overexposed by a considerable amount if there is a huge difference between the brightness of the subject and its background.

The shot of the bird below would come out perfectly exposed whatever metering system was used, despite having a full range of tones from black to white. The out of focus background is not that different in tone from

MIDTONE
Despite containing both bright white and dark black areas in its plumage, this otherwise mid-toned bird and background could be exposed well using any metering mode.

Focal length: 600mm, Aperture: f/5.6, Shutter speed: 1/250 sec., ISO: 6400

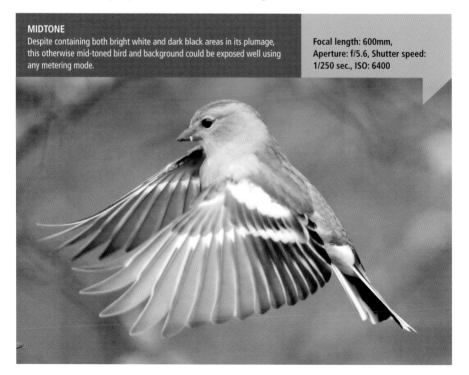

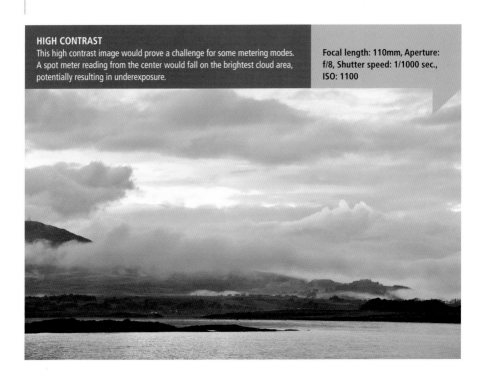

HIGH CONTRAST
This high contrast image would prove a challenge for some metering modes. A spot meter reading from the center would fall on the brightest cloud area, potentially resulting in underexposure.

Focal length: 110mm, Aperture: f/8, Shutter speed: 1/1000 sec., ISO: 1100

the average tones of the bird itself, so matrix or evaluative metering of the whole frame would be effective. The same would apply to centerweighted average metering. As the bird occupies most of the frame, partial metering would concentrate on an area largely consisting of the gray wings—a perfect midtone—while a spotmeter reading at the center would also measure a small area of the midtone wings (as long as the larger white patch was missed).

The landscape image (above) is a different matter altogether. This also has a full range of tones, but it is where these lie in the frame that makes the difference. There is just about

sufficient midtone cloud for matrix or evaluative metering patterns to get close to the optimum exposure, but the darker tones at the bottom of the frame would be missed by partial metering and may not be allocated enough bias using centerweighted metering. A spotmeter reading from the center of the frame would target the brightest part of the image and result in an underexposed image, making this a good case for metering from a different part of the scene, locking the exposure, and re-framing the shot. A spot reading taken from the darker cloud immediately above the hill to the left of the image would work well.

What went wrong?

Here we examine several images that display commonly encountered problems.

Incorrect white balance

ASSESSMENT
The image is too "warm" and was captured using a white balance setting that would be better suited to a cloudy day. This is usually easy to spot when you know what certain colors should look like: in this case the sky, grass, and trees are a giveaway.

Focal length: 50mm,
Aperture: f/11, Shutter speed: 1/25 sec., ISO: 100

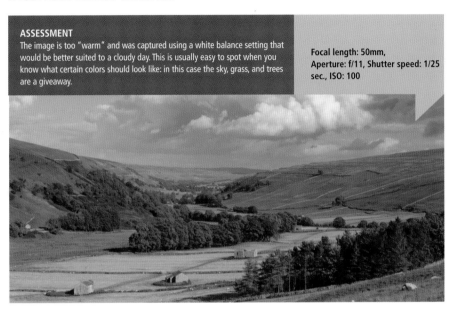

Solution
Change the camera's white balance setting to Sunny.

Alternative solution
If your camera has the facility, use the white balance bracketing feature. This normally records three different images, each at a different color temperature, with a single press of the shutter release. It can often be combined with auto exposure bracketing,

so if 3-shot AEB is selected (pro cameras may offer up to 9-shot AEB), each exposure will be made with three different white balance settings, recording nine images in total.

Rescue the original image
If the image was captured as a RAW file, changing the color temperature can be done easily during post-processing. If shot as a JPEG file, some post-processing adjustment will still be possible, but it will be more time-consuming.

Metering fooled

ASSESSMENT
The reason for this underexposed image is immediately obvious: the metering mode has placed the emphasis on the center of the image, which includes areas of bright sky and water that is reflecting the sky.

Focal length: 24mm,
Aperture: f/16, Shutter speed:
1/250 sec., ISO: 1600

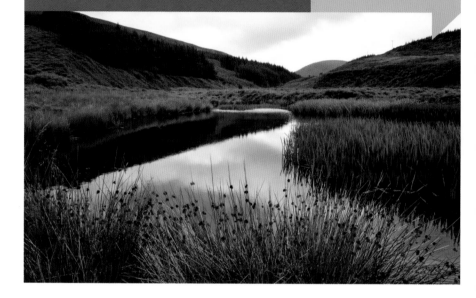

Solution

Select a metering mode that takes into account all areas of the image, without bias, and/or use in-camera balancing tools such as Canon's Auto Lighting Optimizer or Nikon's Active D-Lighting.

Alternative solution

Take a meter reading from a midtone, such as the grass to the left, and set the exposure manually. This alone would cause loss of cloud detail in this case, so consider bracketing exposures with each shot ⅓- to ⅔-stop apart.

RESCUE THE ORIGINAL IMAGE

The main issue with the first image is its high contrast, which can be reduced in-camera or during post-processing. However, this can lead to a very "flat" result. A subtle increase in color saturation will help improve things, along with a slight adjustment to the blacks in Photoshop using the Levels tool, moving the Input Level slider from 0 to whatever looks right for the image.

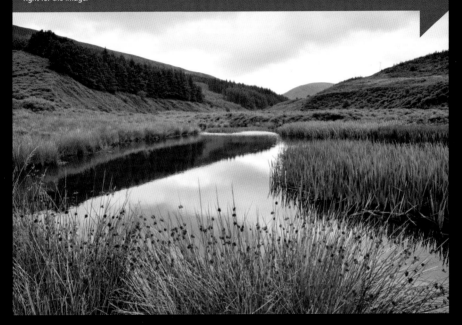

Shooting into the sun

Focal length: 24mm, Aperture: f/8
Shutter speed: 1/2000 sec.,
ISO: 200

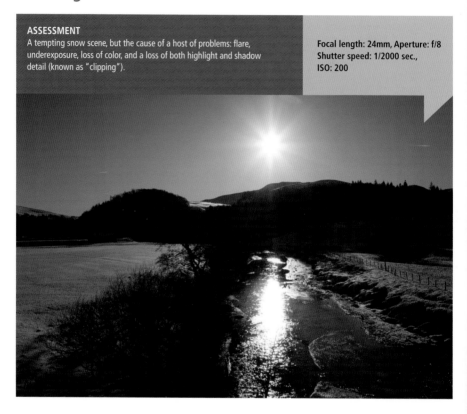

Solution

Not everything that is attractive to the eye makes a good photograph and the contrast is simply too high here. Shooting a sequence for HDR is one solution, otherwise you simply have to accept the limitations of the camera and look around for alternative opportunities.

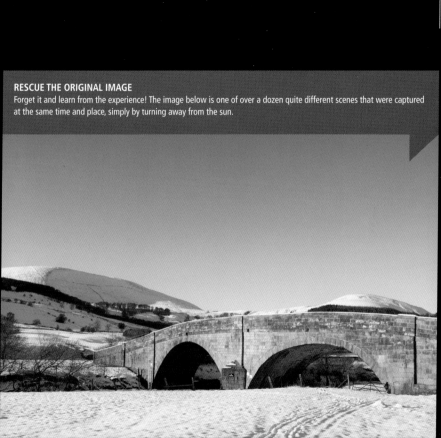

RESCUE THE ORIGINAL IMAGE
Forget it and learn from the experience! The image below is one of over a dozen quite different scenes that were captured at the same time and place, simply by turning away from the sun.

Wrong metering mode

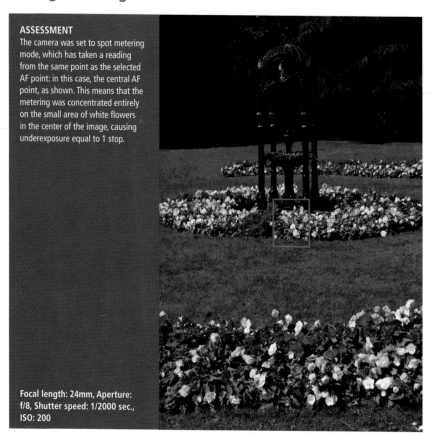

Focal length: 24mm, Aperture: f/8, Shutter speed: 1/2000 sec., ISO: 200

Solution

Always be aware of the metering mode currently selected on the camera and of the position of the brightest and darkest parts of the scene to be photographed, particularly if they are central.

Alternative solution

If you are using your camera's spotmeter mode, meter from a midtone area such as grass. Alternatively, take two readings: one from the brightest part of the scene and one from the darkest part, then average the two readings.

RESCUE THE ORIGINAL IMAGE
In this instance, a simple adjustment to the exposure in post-processing is all that
is required.

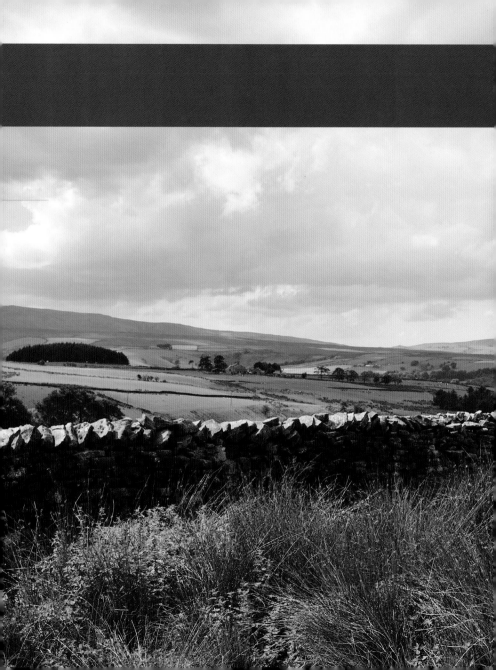

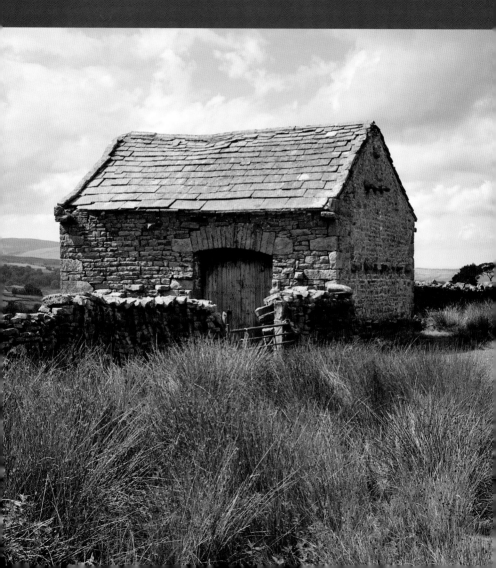

CHAPTER 3 APERTURE

Aperture

Definition: The size of the diaphragm opening within the camera lens construction, through which light rays are admitted, expressed as an f-number (for example, f/5.6). For any given exposure the aperture has a direct relationship with shutter speed and is the most commonly adjusted factor when determining depth of field.

As mentioned previously, the aperture is an opening in the camera's lens that allows light to pass through to the film or sensor, making it one of the fundamental exposure controls. However, in addition to simply regulating the amount of light that passes through it, the aperture also has a profound effect on the appearance of an image, in terms of depth of field, making it a creative—as well as technical—control. Depth of field is explored more fully in the following chapter, although it is referred to frequently here as it is necessary to have some understanding of it in order to appreciate the importance of your camera's aperture setting.

FACTORS

Light available
Maximum/minimum lens aperture
Depth of field
Shutter speed
ISO setting
Focal length

Camera modes

The vast majority of shooting and exposure modes built into digital cameras are there for the amateur or less technically-minded enthusiast. Professional cameras are, at least in this respect, usually devoid of all but the basic exposure modes: Manual, Aperture Priority, Shutter Priority, and Program.

Of these primary exposure modes, Aperture Priority is the one we are most concerned with in this chapter. In this mode, the user selects the aperture and the camera selects a corresponding shutter speed according to the meter reading. The third factor to bear in mind in this equation is the ISO speed, which can usually be set manually or automatically (see also Chapter 6).

Aperture Priority is usually selected with depth of field (DoF) in mind, because either a shallow or a deep DoF is required. Aperture Priority is also the usual mode of choice when using flash, because the aperture selected has an impact on how far the illumination of the flash will carry. However, there can be other circumstances that demand Aperture Priority, such as when using older, manual focus lenses

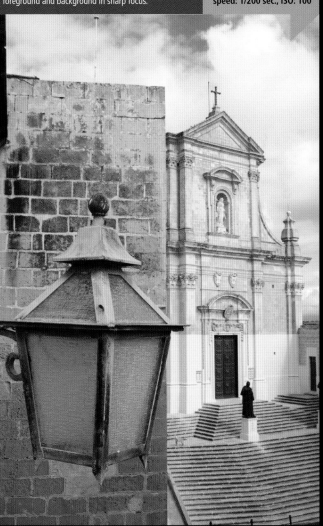

SMALL APERTURE
Images such as this demand a small aperture setting to deliver the depth of field necessary to keep both the foreground and background in sharp focus.

Focal length: 28mm, Aperture: f/11, Shutter speed: 1/200 sec., ISO: 100

on modern DSLR bodies that prevent Shutter Priority from being selected (as is the case with Nikon DSLR cameras, for example).

Canon also provides A-DEP mode, which is short for automatic depth of field auto exposure. Any autofocus point settings are overridden so that all AF points are used, with the camera looking to extract focus information on the nearest and furthest points focused on. A suitable aperture is then automatically chosen so that the required depth of field is provided to keep everything from the nearest to furthest points in focus. A corresponding shutter speed is also selected automatically, secondary to the aperture selection process.

Exposure bracketing

Any camera offering Aperture Priority will also provide the facility for *auto exposure bracketing* (AEB). With AEB and Aperture Priority selected, the camera will take several shots at different shutter speeds. If three shots are to be taken (some cameras offer more than this) the camera will take one shot at the exposure setting suggested by the meter, plus one at a greater exposure and one at a lower exposure. The gap or *exposure increment* between shots can usually be changed, so it may be 1 stop, ½ stop, or ⅓ stop.

The images to the right were bracketed 1 stop apart and, as you can see, this makes a huge difference to the image as a whole.

EXPOSURE BRACKETING
Top: one stop below meter reading

Middle: the nominally correct image according to the camera's meter reading

Bottom: one stop higher than meter reading

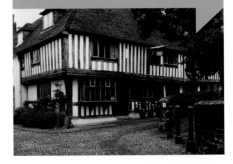

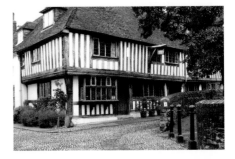

Exposure compensation

Another feature commonly available is *exposure compensation*, which allows you to manually adjust the exposure suggested by the meter. The maximum degree of adjustment may be as little as 2 stops either side of the nominal exposure, more commonly 3 stops, occasionally 5, and on some pro-spec cameras even more. Again, the exposure increment can usually be changed to suit the circumstances: the menu above shows -2 stops of exposure compensation (to darken the exposure), applied in ⅓-stop increments.

Apart from these main exposure modes, there is a huge range of what are generally referred to as "scene modes," but which the facetious, quite unfairly, insist on calling "idiot modes." Don't be put off when you come across such slang: we all have to start somewhere, and photography is most definitely a lifelong learning experience.

Of all the scene modes offered, Landscape mode is guaranteed across a wide range of cameras. Regardless of the make or model of camera, this will invariably select an aperture that provides the greatest depth of field of all

Tip
On most cameras offering both exposure compensation and auto exposure bracketing, the two functions can be used simultaneously. This menu shows -5 stops of exposure compensation, with exposure bracketing set to capture two additional images at -8 stops and -2 stops under. The exposure increment is set to ⅓ stop for both operations.

the scene modes available, but it will also select many other settings automatically, including the ISO. Therefore, you should be aware that the Landscape scene mode may force the camera to set a high ISO setting, which is especially important if you're using a compact camera with a sensor smaller than the standard APS-C size used in a DSLR. If this is the case, the increased ISO might mean that the end result has a lot more "noise" than you would like. As we will see in Chapter 6, noise can effectively spoil a picture.

Depth of field: a brief outline

Every subject we focus on lies on a single plane of sharp focus. In front of, and behind, that plane there is a gradual transition toward being out of focus, and at some point within this transition relative sharpness becomes unacceptable, at which time we start to use the term "out of focus." The zone of acceptable focus is what we call depth of field (DoF), and it can be as shallow as 1mm or as extensive as the eye can see, depending on several factors.

Both of the images shown here were captured at f/11, but using two very different focal lengths. The image of the barn was captured using a 35mm lens and the depth of field extends from the reeds in the foreground right into the distance: everything appears sharp.

The shot of the heron was also taken using an aperture setting of f/11, but with a 600mm lens. Despite the aperture being the same as the previous shot, the depth of field covers just a few inches—a result of the longer focal length.

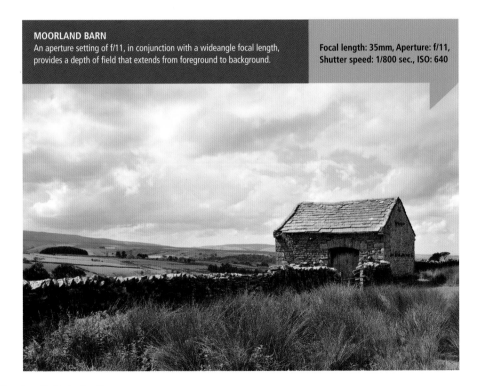

MOORLAND BARN
An aperture setting of f/11, in conjunction with a wideangle focal length, provides a depth of field that extends from foreground to background.

Focal length: 35mm, Aperture: f/11, Shutter speed: 1/800 sec., ISO: 640

Zoom lenses

There are many zoom lenses available today with a very wide range of focal lengths. Depending on the metering mode, this can have some bearing on both metering and exposure if you use the readings from one focal length and apply them to an image being captured at a substantially different focal length. This will depend on the scene being captured and the extent to which zooming in (or out) excludes (or includes) any particularly bright or dark areas.

Tip
You can use a zoom lens in a similar way to a spotmeter, zooming in to get a precise reading of an area of the scene that is important, and then zooming out and recomposing the shot once you have set the exposure, but before triggering the shutter.

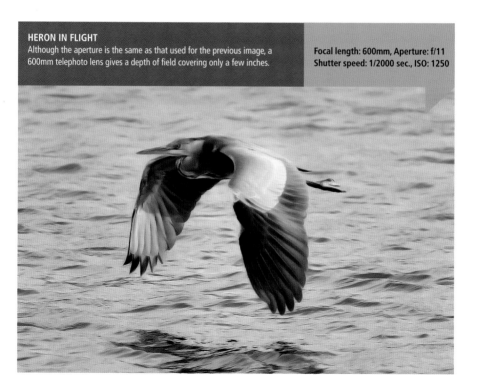

HERON IN FLIGHT
Although the aperture is the same as that used for the previous image, a 600mm telephoto lens gives a depth of field covering only a few inches.

Focal length: 600mm, Aperture: f/11
Shutter speed: 1/2000 sec., ISO: 1250

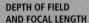

Focal length: 70mm, Aperture: f/11, Shutter speed: 1/250 sec., ISO: 200

Focal length: 220mm, Aperture: f/8, Shutter speed: 1/500 sec., ISO: 200

DEPTH OF FIELD AND FOCAL LENGTH
Although the overall exposure is the same for both of these images, a wider aperture could be used for the close-up of the clock as it didn't need such a large depth of field.

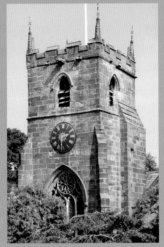

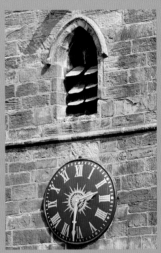

In the examples shown opposite, the metering and therefore selected exposure value were the same for the two different images, which were shot from the same distance (but not quite the same position) using a 70–300mm lens. The reason the exposure value remains the same for both is because the range and extent of the tones are much the same, as seen when they are converted into black and white.

However, there is a significant difference: the close up of the church clock requires a minimal depth of field, so a wider aperture could be used along with a faster shutter speed. This is useful when using a long focal length as it helps to minimize camera shake. So, when zooming in or out, it's not just a matter of whether the exposure suggested by the meter changes, it is also important to realise that the depth of field requirements may well change too.

Diffraction

So why don't we just use the smallest aperture on the lens for the greatest depth of field? Well, just as we sometimes avoid the widest aperture settings when we want optimum image quality, so there is also a performance loss at the smallest apertures, caused by diffraction.

When light waves are made to change direction there is a loss of quality, and the light waves passing through a lens are not only redirected by the individual glass elements within the lens, but they are also redirected as they pass through the aperture before they reach the film or sensor.

Undeflected light waves at the center of an image give us the highest image quality as they are redirected least of all, but the smaller the aperture, the greater the proportion of light that is affected, and this results in a degree of diffusion and an apparent loss of sharpness. This loss of sharpness is known as *diffraction* and is why, for absolute detail and the biggest enlargements, the smallest apertures on a given lens may need to be avoided.

As with so many aspects of photography, though, it is a trade-off: a wider aperture means less depth of field, but what is in focus is extremely sharp, while a smaller aperture will give you greater depth of field with slightly less apparent sharpness. What should determine your choice is the size at which the final image will be displayed, and the distance between the image and the viewer.

Tip
As the outer extremes of an image may be subject to color aberration (often abbreviated to CA), depending on the quality of the lens used, this is another good reason why you may want to avoid using the smallest aperture settings on your lens. If you are using a crop-sensor DSLR, the best advice is to use full-frame lenses whenever possible as the smaller sensor size will mean that you are using the central portion of the lens's image-circle, which is where definition is at its best and unwelcome aberrations are generally absent.

Macro photography

Technically speaking, macro photography refers to capturing images at life-size, but many modern zoom lenses offer a "macro" capability that allows you to shoot close-ups that are greater in magnification than the lens design would normally permit. Such lenses may only offer magnification of ⅕ life-size, so are not "true" macro lenses, but they do at least give you a close-up option.

The exposure is unlikely to need modification with a dedicated macro lens (or a macro setting on a zoom) unless you use extension tubes or bellows that don't permit full use of the camera's through the lens (TTL) metering system. In these circumstances, the light lost by fitting a long dark tube between the camera and lens needs to be accounted for. The math involved is complex, so the easiest solution is to take test shots and/or bracket your exposures.

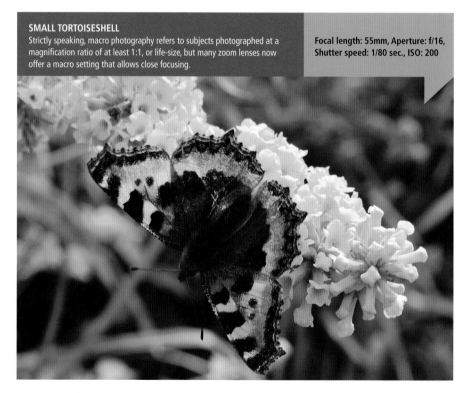

SMALL TORTOISESHELL
Strictly speaking, macro photography refers to subjects photographed at a magnification ratio of at least 1:1, or life-size, but many zoom lenses now offer a macro setting that allows close focusing.

Focal length: 55mm, Aperture: f/16, Shutter speed: 1/80 sec., ISO: 200

What went wrong?

Here we examine several images that display commonly encountered problems.

Aperture too narrow

ASSESSMENT
I would have preferred to have more of the background in focus, but even an aperture setting of f/11 hasn't proved sufficient with a 600mm focal length.

Focal length: 600mm, Aperture: f/11, Shutter speed: 1/2000 sec., ISO: 1250

Assessment

On the face of it, there's nothing "wrong" with this image, except that it was not what was intended. And intention is an important issue; otherwise our "good" images would simply be happy accidents. This scene unfolded as dramatic lighting passed through the location where I was photographing birds, but as the light was changing quickly this was very much a "grab shot." However, I wanted the darker conifers in the background to be slightly in focus and, seeing f/11 indicated in the viewfinder, I figured the aperture was sufficient. Truth is, I forgot I had a 600mm lens attached, which provides a minimal depth of field, even at this aperture.

Solution

Set an aperture suitable for the scene and for the focal length in use, using the camera's depth of field preview as a guide.

Alternative solution

For a greater depth of field at a given aperture, switch to a shorter focal length and crop the image during post-production.

Rescue the original image

The best software in the world cannot transform an out of focus subject into a correctly focused one.

Aperture too wide

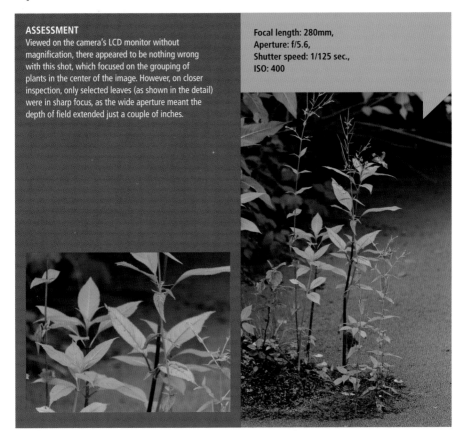

Focal length: 280mm,
Aperture: f/5.6,
Shutter speed: 1/125 sec.,
ISO: 400

Solution

Select a smaller aperture, which may necessitate using a camera support or a higher ISO setting. A higher ISO may introduce noise into shadow areas, but exposure is almost always a matter of compromise!

Alternative solution

Shoot with a wider focal length and crop the image during post processing.

RESCUE THE ORIGINAL IMAGE
Here, the answer is to crop extensively so the purple flower that is sharp becomes
the main item of interest. Any out of focus leaves become relatively unimportant.

Lens choice

Focal length: 105mm,
Aperture: f/5.6, Shutter speed:
1/125 sec., ISO: 100

Solution

Use a longer focal length. In this case, a slight increase in exposure might have been required, as the main subject was appreciably darker than the surrounding pasture and would have occupied a greater proportion of the frame.

Alternative solution

If possible, move closer. This works best if you are at the same height as the subject, but that would change this particular image. The base of the stone wall behind the sheep would be lower in relation to them, so they would no longer be isolated against the light grass.

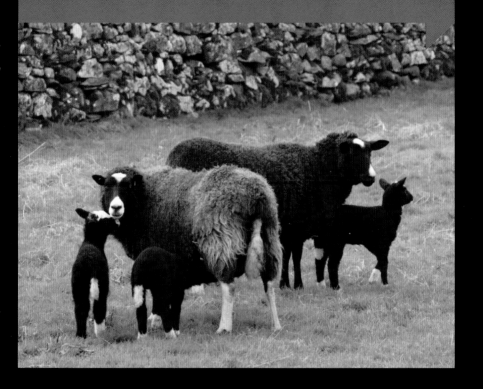

RESCUE THE ORIGINAL IMAGE
Assuming the main subject is sharp enough, this would be an easy image to crop in a variety of ways.

Vignetting

ASSESSMENT

Vignetting is the term applied to describe the darkening of the corners of an image. The most common cause is the use of an incorrect lens hood, although fitting a lens hood onto a filter (or several filters) mounted on the front of the lens may also cause corner-shading.

Focal length: 24mm, Aperture: f/11, Shutter speed: 1/250 sec., ISO: 640

Solution

With the intended aperture selected and filter(s) plus lens hood fitted, point the camera at the sky or a similar bright and evenly-lit area, then press the depth of field preview button on your camera to stop down the lens to the aperture you will be taking your shot at. Any vignetting in the corners will be immediately apparent.

Alternative solutions

Remove the lens hood, but not the filter(s), and shield the lens from the sun or other lightsource with your hand, a piece of card, a hat, or anything else that's suitable.

Rectangular filter systems will not cause problems with vignetting if the filters are large enough.

RESCUE THE ORIGINAL IMAGE

Because there is a tendency for all lenses to be slightly darker in the corners owing to light fall-off, post-processing software often includes an option to even out the illumination. This will also reduce any vignetting created by a lens hood, although it is unlikely to remove it entirely. If available, it is worth trying this first, followed by cropping to rid the image of any remaining evidence.

CHAPTER 4 DEPTH OF FIELD

Depth of field

Definition: A zone within the image, usually including the primary subject, which is deemed to be in acceptable apparent focus.

FACTORS
Camera-to-subject distance
Lens focal length
Selected aperture
Circle of confusion

Depth of field, focal length, and aperture

There are two simple rules to remember regarding depth of field and its relationship to focal length and the aperture setting. These are:

- The wider the aperture, the smaller the depth of field (and vice versa)
- The longer the focal length, the smaller the depth of field (and vice versa)

The combination of a wide aperture and a long focal length will therefore produce a very small (or shallow) depth of field, while a small aperture setting and a wideangle focal length will produce a much greater (or deeper) depth of field. With manufacturers producing large numbers of zoom lenses with wide ranges such as 18–200mm, it is all too easy to whiz from one end of the focal length range to the other, and back again, without giving much thought to the differing aperture requirements. But an aperture setting of f/8 will produce a markedly different depth of field at each end of the zoom range.

It is also worth remembering that a lot of these zoom lenses are quite "slow" in terms of their maximum aperture setting, typically providing a maximum aperture of f/4.5–5.6. This makes them quite light, but they are still heavier and bulkier than most fixed focal length (prime) wideangle, standard, and even some short telephoto lenses with much faster maximum apertures. The latter will often provide better image quality and better low-light performance as well.

Tip

Fixed focal length lenses with wide
maximum apertures, such as this 300mm
f/2.8 (above) and super-wide 15mm f/2.8
(right) are expensive items, even if you buy
a used lens. But there is an alternative.

Many professionals at certain types
of sporting event will use manual focus,
focusing on a given point and waiting
for the action to come to them. Similarly,
many pro landscape photographers will use
manual focus on their wideangle lenses in
order to set the hyperfocal distance and get
the best depth of field. In both examples,
an older manual focus lens would do just
as well as a modern, autofocus equivalent,
but it could cost a fraction of the price.

Circle of confusion

While DoF can be calculated mathematically using the focal length and aperture setting, its impact is also very dependent upon the size of the image when viewed, so to some extent it is a subjective issue. A key factor that affects sharpness in the printed image—and therefore also comes into play when assessing what appears to be in sharp focus—is called the circle of confusion (CoC). This is the size of an area of the image at which light rays cease to focus to a point and instead come together as a small circle. In human terms, it is the largest spot that our eyes still perceive as a point.

Prints are generally viewed from a distance slightly greater than their diagonal measurement, based on the eye's ability to resolve 5 lines/mm at a viewing distance of 25cm. The circle of confusion is usually expressed in millimetres or microns (1 micron = 1/1000mm) and for 35mm film and full-frame digital sensors the CoC is generally accepted as 0.030mm or 30 microns. Really this is the maximum permissible circle of confusion for this format, as anything greater would be unacceptable (resulting in a soft image), while anything smaller would always appear sharp.

Each film or sensor format has its own suggested CoC figure and, for a crop-sensor camera, this can be found by dividing the full-frame CoC of 30 microns by the crop factor. For example, with a Nikon DX format sensor with a crop factor of 1.5, the CoC would be 30/1.5, or 20 microns (0.020mm). Any camera offering a range of image sizes (3:2, 4:3, 16:9, and so on) needs a different CoC for each.

If you decide—in order to improve print sharpness—to use a smaller CoC than is suggested for your sensor format, then the mathematical outcome is much the same: you will end up using a narrower aperture than is suggested by a depth of field (DoF) table or the DoF scale on your lens, provided they have been computed according to the commonly accepted CoC sizes shown below.

If the sensor size, focal length, aperture, and focus distance all remain constant, reducing the CoC will have the following impact on DoF calculations:

- The near limit of acceptable focus will be further away
- The far limit of acceptable focus will be closer
- The depth of focus in front of the subject will be reduced
- The depth of focus behind the subject will be reduced
- The hyperfocal distance will be further away

If your foreground is more out of focus than it should be for the distances involved, despite

COMMONLY ACCEPTED COC

Digital compact	0.005mm / 5 microns
Nikon DX series	0.020mm / 20 microns
Canon 1D series	0.023mm / 23 microns
Full-frame/35mm film	0.030mm / 30 microns
645 (6x4.5cm) film	0.052mm / 52 microns
6x6cm film	0.056mm / 56 microns

using either the DoF scale on the lens or a separate DoF table, it could be that the scale/ table was computed using a different CoC to the one that suits your technique or your printing requirements. One simple solution is to use an aperture setting that is 1 stop smaller than the aperture indicated on the DoF scale/ table; shooting at f/16, but using the DoF markings on your lens for f/11, for example.

Unfortunately, meaningful DoF scales are rapidly disappearing from many lenses. The increased use of plastics in modern lens construction has also left us without a fixed infinity mark on many lenses, to allow for thermal expansion.

HYPERFOCAL DISTANCE

The hyperfocal distance at a given aperture is the closest point of focus at which infinity falls within the depth of field. This is the point at which you would focus to ensure that everything from that point to infinity is in focus, along with a significant zone in front of it. Using manual focus, turn the focus ring so that the infinity mark is just inside the mark for the selected aperture on the depth of field scale. The equivalent mark at the other end of the scale shows the closest point that will be in focus.

HYPERFOCAL DISTANCE
The hyperfocal distance varies depending on focal length and aperture, but it is the closest point at which infinity will fall within the depth of field.

Focal length: 60mm,
Aperture: f/11, Shutter speed:
1/500 sec., ISO: 200

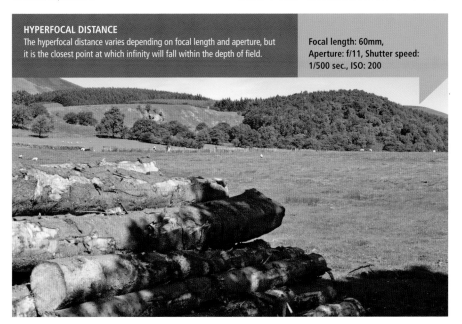

Extensive depth of field

If you want to maximize the depth of field in an image, you need to use a small aperture and/or a wider focal length. Your choice of focal length is important, however, because the wider the focal length, the more the distant elements will be rendered smaller and smaller in the composition, which can change the whole feel of the image.

There is also a cut-off point with regards to focal length and technique. With lenses as wide as 24mm on a full-frame camera you can use them to simply widen your view, especially by stepping back a couple of paces, capturing scenes such as the one below. However, at wider focal lengths, you need to change your technique and *step forward* to increase the relative size of the foreground. This means that you must be actively looking for items that will provide prominent foreground interest.

MAXIMUM DEPTH OF FIELD
A wideangle lens, or focal length setting, used with a wide aperture will produce the greatest depth of field, making it the ideal choice for landscapes.

Focal length: 35mm, Aperture: f/16, Shutter speed: 1/500 sec., ISO: 200

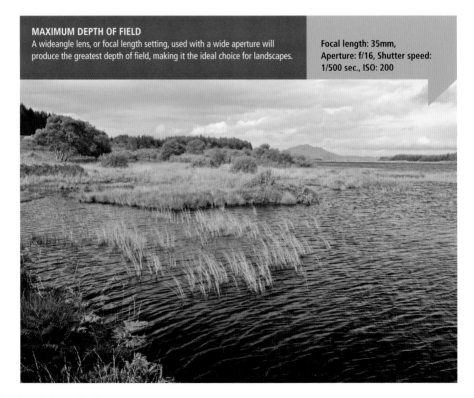

COMPOSITION AND DEPTH OF FIELD

A simple technique for adding foreground is to rotate your camera and shoot a vertical image. When combined with a wider focal length this can add great immediacy to the foreground. However, if there is no separation in terms of distance from the camera position, you may well need to use the narrowest aperture available and set the hyperfocal distance to get everything sharp.

In the top image shown here, an aperture of f/10 was used and you can see that the surface of the wall nearest the camera isn't quite sharp. By comparison, the bottom image was achieved with an aperture of only f/4.

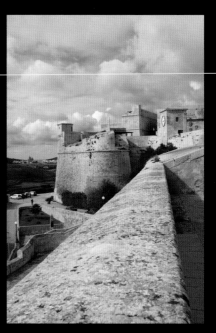

Above:
Focal length: 24mm,
Aperture: f/10,
Shutter speed: 1/320
sec., ISO: 100

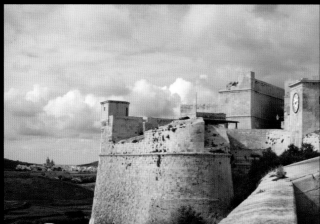

Left:
Focal length: 40mm,
Aperture: f/4, Shutter
speed: 1/1600 sec.,
ISO: 100

Shallow depth of field

By using a wide aperture in conjunction with a longer-than-normal focal length, it is possible to render the background out of focus and add extra "punch" to the subject. The wider the aperture and/or the longer the focal length, the greater the extent of the effect will be. This can be useful for practical reasons, as well as helping to emphasize the subject. For example, it can help you to minimize a distracting or unsightly background, and with a long focal length you can make a background disappear into a blur.

Does this mean that you don't need to pay attention to the background at all? No, you still need to be aware of what is there, because the colors will still be in evidence, even if the detail is not. In the image of the fisherman sorting his nets below, the bright colors add vibrancy to the photo, but watch for large areas of strong reds and yellows, as these can distract the viewer.

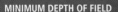

MINIMUM DEPTH OF FIELD
A telephoto lens, or focal length setting, used with a small aperture will produce a very shallow depth of field—perfect for making a subject stand out from the background.

Focal length: 105mm, Aperture: f/4, Shutter speed: 1/1250 sec., ISO: 100

Tip

When the light levels are very low, and you have a reasonably wide maximum aperture available on the lens you are using, there is no need to stop looking for subject matter—even if you want to maintain a low ISO for maximum quality. Instead, look out for two-dimensional subject matter that doesn't require an extensive depth of field, such as this interesting door in Malta.

EXPOAPERTURE2

This clever idea from Expo Imaging comes in the form of a pair of double-sided plastic dials, one for telephoto lenses and another for wide/standard focal length lenses (macro use is also catered for). Each dial is used to determine the aperture and focus setting needed for the required depth of field. Because each dial allows you to select a suitable circle of confusion for the camera in use, you can carry different systems and a wide range of lenses without a lot of different DoF tables. Each set comes with two dials, instructions, and a CD with a guide to everything concerning depth of field. For further information, visit www.expoimaging.com.

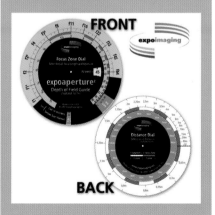

Reflections

Photographing reflections can be extremely rewarding, but, the camera-to-subject distance—and therefore the depth of field—can be an issue. It is important to remember that when the camera focuses on a reflection, it is probably not focusing on the reflective surface, but on the subject matter that is being reflected.

When capturing reflections on a large scale and at some distance from the reflective surface, this is less of an issue, as both the surface and the reflection will be close to infinity in focusing terms. However, if you are trying to photograph a reflection in a smaller object—a shiny door knob, for instance—you may find that the lens is focusing on the reflection (at several feet), rather than the object it is reflected on (which may only be several inches away) or vice versa. To a certain extent this depends on the reflectiveness of the surface and therefore the quality of the reflection, but be aware that the reflection itself may well appear out of focus.

REFLECTED COLOR
In this shot of reflections in the colorful harbor of Tobermory on the Isle of Mull, both the water and the reflected subject are at infinity focus, so both are as sharply focused as they can be.

Focal length: 185mm, Aperture: f/11, Shutter speed: 1/320 sec., ISO: 200

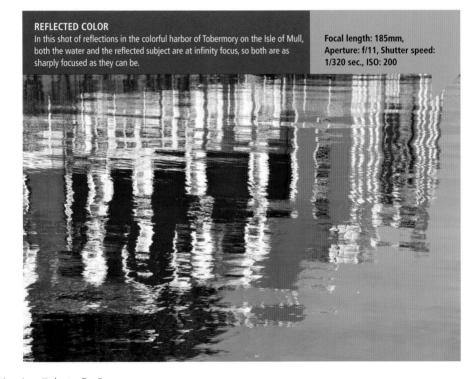

Canon's DEP and A-DEP modes

For many years Canon DSLRs have sported an A-DEP mode. With this setting the camera determines the aperture needed from the focusing information. In reality, this often sets a wider aperture than is needed so using Aperture Priority is often the better solution.

However, Canon provided a more useful DEP mode on some of its earlier cameras. This worked by focusing twice: once on the nearest point you wanted in focus, and then on the furthest point. This gave the camera more information to work with and the system worked quite well.

AUTOMATIC DEPTH OF FIELD
Using the information from numerous focus points, Canon's A-DEP mode attempts to set an aperture that will provide sufficient depth of field to keep the entire image sharp.

Focal length: 17mm, Aperture: f/5.6, Shutter speed: 1/400 sec., ISO: 100

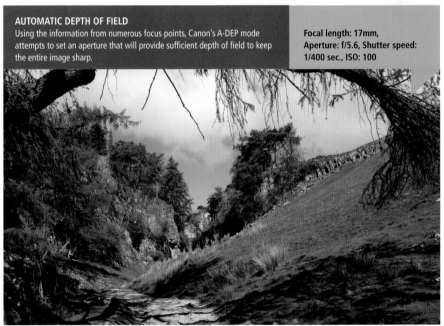

TYPICAL DEPTH OF FIELD TABLES

Lens	**Nikon 20mm f/2.8 AF-D**						

Focused Distance (m)		f/2.8	f/4	f/5.6	f/8	f/11	f/16	f/22
0.25	Near	0.244	0.242	0.239	0.235	0.230	0.222	0.214
	Far	0.256	0.259	0.262	0.268	0.276	0.291	0.312
0.3	Near	0.290	0.287	0.282	0.275	0.267	0.254	0.242
	Far	0.311	0.315	0.322	0.333	0.348	0.377	0.422
0.4	Near	0.380	0.372	0.362	0.348	0.332	0.310	0.288
	Far	0.432	0.435	0.451	0.477	0.517	0.604	0.768
0.5	Near	0.465	0.452	0.435	0.413	0.389	0.356	0.325
	Far	0.542	0.563	0.593	0.647	0.732	0.954	1.53
0.7	Near	0.626	0.599	0.567	0.526	0.484	0.428	0.379
	Far	0.797	0.849	0.931	1.09	1.40	2.82	Inf
1.0	Near	0.844	0.793	0.734	0.661	0.591	0.505	0.433
	Far	1.23	1.38	1.63	2.27	4.61	Inf	Inf
2.0	Near	1.42	1.27	1.11	0.94	0.79	0.64	0.52
	Far	3.44	5.02	13.35	Inf	Inf	Inf	Inf
Inf	Near	5.0	3.2	2.3	1.6	1.2	0.9	0.6
	Far	Inf	Inf	Inf	Inf	Inf	Inf	Inf

Lens	**Nikon 35mm f/2 AF-D**								
Focused Distance (m)		**f/2**	**f/2.8**	**f/4**	**f/5.6**	**f/8**	**f/11**	**f/16**	**f/22**
0.25	Near	0.249	0.249	0.248	0.247	0.246	0.245	0.243	0.240
	Far	0.251	0.251	0.252	0.253	0.254	0.256	0.258	0.262
0.3	Near	0.298	0.297	0.296	0.295	0.293	0.290	0.286	0.281
	Far	0.302	0.303	0.304	0.305	0.308	0.311	0.316	0.323
0.35	Near	0.347	0.346	0.344	0.342	0.339	0.335	0.328	0.321
	Far	0.353	0.354	0.356	0.359	0.363	0.368	0.376	0.388
0.4	Near	0.396	0.394	0.392	0.388	0.383	0.378	0.369	0.358
	Far	0.404	0.406	0.409	0.413	0.419	0.426	0.439	0.457
0.5	Near	0.492	0.489	0.485	0.479	0.471	0.461	0.445	0.428
	Far	0.508	0.511	0.516	0.523	0.534	0.549	0.575	0.611
0.7	Near	0.682	0.676	0.666	0.653	0.635	0.615	0.583	0.550
	Far	0.719	0.726	0.738	0.755	0.782	0.819	0.890	0.996
1.0	Near	0.961	0.946	0.925	0.898	0.861	0.819	0.759	0.698
	Far	1.04	1.06	1.09	1.13	1.20	1.30	1.51	1.90
2.0	Near	1.83	1.77	1.69	1.59	1.47	1.34	1.17	1.02
	Far	2.20	2.30	2.46	2.71	3.20	4.16	8.50	Inf
Inf	Near	19.5	14.0	9.8	7.0	4.9	3.60	2.50	1.90
	Far	Inf	Inf	Inf	Inf	Inf	Inf	Inf	Inf

TYPICAL DEPTH OF FIELD TABLES

Lens		Nikon 70–300mm f/4.5–5.6 G AF-S VR at 70mm						
Focused Distance (m)		f/4.5	f/5.6	f/8	f/11	f/16	f/22	f/32
1.5	Near	1.45	1.44	1.42	1.39	1.35	1.30	1.23
	Far	1.55	1.56	1.59	1.63	1.69	1.78	1.95
1.7	Near	1.64	1.62	1.59	1.56	1.50	1.44	1.35
	Far	1.77	1.78	1.82	1.87	1.97	2.09	2.35
2	Near	1.91	1.89	1.85	1.80	1.72	1.64	1.52
	Far	2.10	2.12	2.18	2.26	2.40	2.60	3.03
3	Near	2.78	2.74	2.65	2.54	2.37	2.20	1.97
	Far	3.25	3.31	3.47	3.69	4.13	4.82	6.76
4	Near	3.61	3.54	3.38	3.19	2.93	2.67	2.33
	Far	4.49	4.60	4.93	5.40	6.45	8.43	17.63
5	Near	4.40	4.29	4.04	3.78	3.40	3.05	2.60
	Far	5.81	6.01	6.59	7.49	9.73	15.28	Inf
10	Near	7.76	7.42	6.69	5.96	5.05	4.27	3.41
	Far	14.1	15.4	20.2	32.92	Inf	Inf	Inf
Inf	Near	33.2	27.5	19.3	14.1	9.74	7.14	4.96
	Far	Inf	Inf	Inf	Inf	Inf	Inf	Inf

One of the things you will notice from each of these depth of field tables, but most noticeably in the one above, is that focusing on infinity is not the best way to get maximum depth of field. If you look at the f/32 column you will see that focusing on infinity gives a depth of field stretching from 4.96 meters to infinity.

Yet focusing on a point 5 meters away, at the same focal length, gives a depth of field that extends from 2.6 meters to infinity, which means that more than 2 meters of additional foreground is in focus. To achieve the maximum depth of field, you will need to focus at the hyperfocal distance.

Lens		Nikon 70–300mm f/4.5–5.6 G AF-S VR at 135mm					
Focused Distance (m)		f/5.6	f/8	f/11	f/16	f/22	f/32
1.5	Near	1.48	1.48	1.47	1.45	1.44	1.41
	Far	1.52	1.52	1.53	1.55	1.57	1.60
1.7	Near	1.68	1.67	1.66	1.64	1.62	1.58
	Far	1.72	1.73	1.75	1.77	1.79	1.84
2	Near	1.97	1.95	1.94	1.91	1.88	1.83
	Far	2.03	2.05	2.07	2.10	2.14	2.21
3	Near	2.92	2.89	2.85	2.79	2.72	2.61
	Far	3.08	3.12	3.17	3.25	3.35	3.54
4	Near	3.86	3.80	3.73	3.62	3.50	3.32
	Far	4.15	4.22	4.31	4.47	4.68	5.08
5	Near	4.78	4.69	4.58	4.41	4.23	3.96
	Far	5.25	5.36	5.51	5.78	6.14	6.87
10	Near	9.11	8.77	8.39	7.82	7.24	6.44
	Far	11.09	11.64	12.4	13.93	16.38	23.20
Inf	Near	97.9	68.61	49.97	34.43	25.11	17.35
	Far	Inf	Inf	Inf	Inf	Inf	Inf

TYPICAL DEPTH OF FIELD TABLES

Lens		Nikon 70–300mm f/4.5–5.6 G AF-S VR at 200mm					
Focused Distance (m)		f/5.6	f/8	f/11	f/16	f/22	f/32
1.5	Near	1.49	1.49	1.48	1.48	1.47	1.46
	Far	1.51	1.51	1.52	1.52	1.53	1.55
1.7	Near	1.69	1.69	1.68	1.67	1.66	1.64
	Far	1.71	1.72	1.72	1.73	1.74	1.76
2	Near	1.98	1.98	1.97	1.96	1.94	1.92
	Far	2.02	2.02	2.03	2.04	2.06	2.09
3	Near	2.96	2.95	2.93	2.90	2.86	2.81
	Far	3.04	3.05	3.07	3.11	3.15	3.23
4	Near	3.93	3.91	3.87	3.82	3.75	3.65
	Far	4.07	4.10	4.14	4.20	4.29	4.43
5	Near	4.89	4.85	4.80	4.71	4.61	4.46
	Far	5.11	5.16	5.22	5.33	5.47	5.71
10	Near	9.57	9.40	9.19	8.87	8.51	7.98
	Far	10.47	10.69	10.97	11.48	12.16	13.50
Inf	Near	214.7	150.4	109.5	75.44	54.98	37.93
	Far	Inf	Inf	Inf	Inf	Inf	Inf

Lens		Nikon 70–300mm f/4.5–5.6 G AF-S VR at 300mm					
Focused Distance (m)		f/5.6	f/8	f/11	f/16	f/22	f/32
1.5	Near	1.50	1.49	1.49	1.49	1.49	1.48
	Far	1.50	1.51	1.51	1.51	1.52	1.52
1.7	Near	1.69	1.69	1.69	1.69	1.68	1.67
	Far	1.71	1.71	1.71	1.71	1.72	1.73
2	Near	1.99	1.99	1.99	1.98	1.97	1.96
	Far	2.01	2.01	2.01	2.02	2.03	2.04
3	Near	2.98	2.98	2.97	2.95	2.93	2.90
	Far	3.02	3.03	3.03	3.05	3.07	3.10
4	Near	3.97	3.96	3.94	3.91	3.88	3.83
	Far	4.03	4.05	4.06	4.09	4.13	4.19
5	Near	4.95	4.93	4.90	4.86	4.81	4.73
	Far	5.05	5.07	5.10	5.15	5.21	5.31
10	Near	9.79	9.71	9.61	9.44	9.25	8.94
	Far	10.23	10.31	10.43	10.64	10.90	11.37
Inf	Near	441.5	324.8	236.4	162.8	118.59	81.77
	Far	Inf	Inf	Inf	Inf	Inf	Inf

Comparison of depth of field at different focal lengths with a focused distance of two meters		
Lens	Focused Distance	
Nikon 20mm f/2.8	2.0 meters	Near Far
Nikon 35mm f/2	2.0 meters	Near Far
Nikon 70–300mm f/4.5–5.6 at 70mm	2.0 meters	Near Far
Nikon 70–300mm f/4.5–5.6 at 135mm	2.0 meters	Near Far
Nikon 70–300mm f/4.5–5.6 at 200mm	2.0 meters	Near Far
Nikon 70–300mm f/4.5–5.6 at 300mm	2.0 meters	Near Far

Tip

An easy-to-use web resource for experimenting with DoF calculations can be found at www.dofmaster.com. As well as allowing you to determine the hyperfocal distance for any given focal length and aperture setting, you can also produce your own hyperfocal distance charts, depth of field scales, or simply download an app for your iPod or iPhone.

f/2.8	f/4	f/5.6	f/8	f/11	f/16	f/22
1.42	1.27	1.11	0.94	0.79	0.64	0.52
3.44	5.02	13.35	Inf	Inf	Inf	Inf
1.77	1.69	1.59	1.47	1.34	1.17	1.02
2.30	2.46	2.71	3.20	4.16	8.50	Inf
–	–	1.89	1.85	1.80	1.72	1.64
–	–	2.12	2.18	2.26	2.40	2.60
–	–	1.97	1.95	1.94	1.91	1.88
–	–	2.03	2.05	2.07	2.10	2.14
–	–	1.98	1.98	1.97	1.96	1.94
–	–	2.02	2.02	2.03	2.04	2.06
–	–	1.99	1.99	1.99	1.98	1.97
–	–	2.01	2.01	2.01	2.02	2.03

What went wrong?

Here we examine several images that display commonly encountered problems.

Focus point

ASSESSMENT
The blurred area near the center of this image is actually the bud I wanted to focus on. Unfortunately, the camera has focused on the background instead.

Focal length: 240mm,
Aperture: f/11, Shutter speed:
1/800 sec., ISO: 400

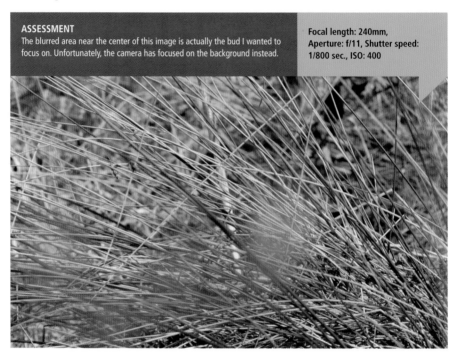

Assessment

The intention in this shot was to capture the new buds. Instead, the background has been recorded with just a hint of blurred bud to the right of center. With a long focal length, subjects closer to the camera can become virtually invisible—useful when shooting through wire mesh fences!

When a multi-AF point focusing mode is used, most cameras will automatically select what they consider to be the main subject—usually the largest identifiable subject closest to the camera. However, they can sometimes "miss" a smaller subject, and even when a single AF point is selected, it is easy to focus on the background by accident.

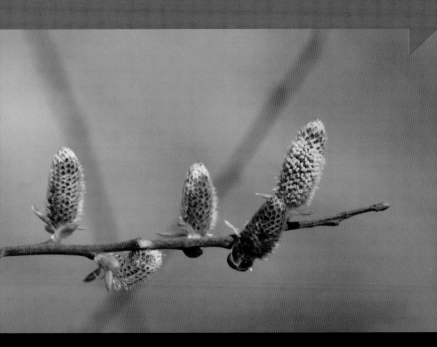

If the camera is set up on a tripod with a remote release being used, it is all too easy to take your eye away from the viewfinder to watch for lighting changes—the sun about to go behind a cloud, for example—before tripping the shutter. During that moment, a heavier camera and lens combination may settle fractionally, causing the autofocus point to just miss the subject you assumed you would be focusing on.

Solution

Use AF lock or switch to manual focus. The use of manual focus may affect the metering mode, depending on your camera, so you may need to use AE lock or switch to manual exposure as well.

Distracting bokeh

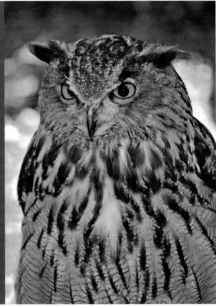

ASSESSMENT
This otherwise splendid portrait of an eagle owl is spoiled by the distracting out of focus highlights (known as "bokeh") in the background, despite tight cropping when the image was captured. When viewed closely, as here, you can see how these highlights have taken on the shape of the aperture, which means they would have been different had a noticeably wider or smaller aperture been selected, depending on the number of blades used by the diaphragm and the shape they form.

Focal length: 300mm,
Aperture: f/8,
Shutter speed:
1/250 sec., ISO: 800

Solution

It is all too easy to concentrate on the main subject when shooting, but it is also necessary to pay attention to the rest of the image, even if it only amounts to a tiny percentage of the whole, as in this example. Use the depth of field preview facility to check not just on what is in focus, but also what is not. Try to be aware of how out of focus highlights will be rendered, and also watch out for small patches of red or yellow in the background, as these can be especially distracting when the main subject comprises of more muted colors.

Alternative solution

Change your camera position so the background is more suitable. When distracting colors are evident, try to position yourself so that the subject masks them. Alternatively, wait until the light on the background changes so that the contrast isn't as great.

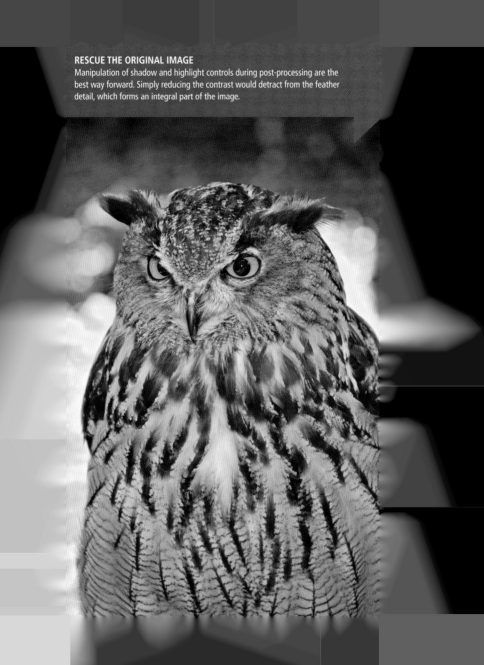

RESCUE THE ORIGINAL IMAGE
Manipulation of shadow and highlight controls during post-processing are the best way forward. Simply reducing the contrast would detract from the feather detail, which forms an integral part of the image.

Not enough impact

ASSESSMENT
Shooting into the light can be both dramatic and effective, and it has the added advantage of enabling excellent depth of field as a small aperture can almost always be achieved. Because a silhouette or near-silhouette is often the outcome, sharpness and depth of field are more noticeable. Shape and line become much more important in the composition too: diagonal lines and triangular shapes create the greatest sense of dynamism. This shot has the potential to be a great image, but the colors are washed out and the oarsman needs more detail in his face to make him "come alive."

Focal length: 240mm,
Aperture: f/11, Shutter speed:
1/800 sec., ISO: 400

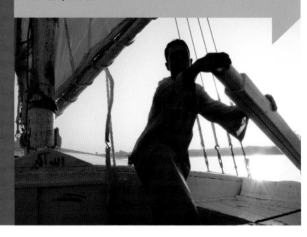

Solution

The balance between highlights and shadows needs delicate adjustment (Canon users have Auto Lighting Optimizer and Nikonians have Active D-Lighting for this), and the color temperature/white balance needs to be considerably warmer. At the very least, the Shade setting should be adopted and saturation increased. If a specific color temperature can be set, then push it as high as possible—even 9000–10,000K won't be too high for this scene.

Alternative solution

An alternative would have been to use a touch of fill-flash, but this would need to be very carefully controlled using flash exposure compensation so that the flash illumination was balanced with the ambient light for the background. Flash exposure compensation works just like ordinary exposure compensation except that it is only applied to the flash. This is usually possible with built-in flash and on the more powerful separate flash units, being set via the camera's own menu settings or controls. An added bonus in this instance would have been the addition of catchlights in the subject's eyes, created by the flash, which always add life to the subject.

RESCUE THE ORIGINAL IMAGE

All the in-camera adjustments described can probably be carried out post-capture on RAW images using the camera manufacturer's own software. If the image was recorded as a JPEG then tone curve adjustments of individual channels (mainly red), reduced overall brightness, and increased saturation will help resolve the color issues. Levels adjustment or highlight/shadow correction will help to bring out the shadow detail.

A matter of scale

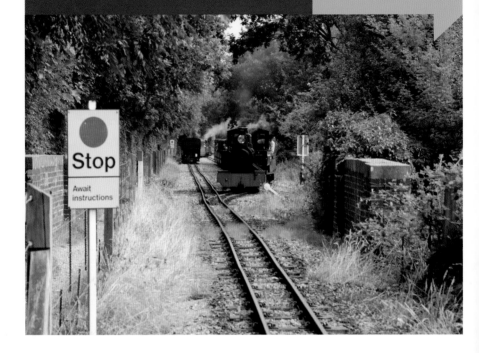

Wait. A well-chosen viewpoint is vital, but so is timing. By allowing the train to come closer, a much more powerful image has been obtained, along with improved depth of field.

Alternative solution

Use a longer focal length lens to increase the relative size of the locomotive. The question then would be whether or not to include the stop sign, as the reduction in depth of field arising from the longer focal length would render the stop sign even more out of focus. Alternatively, use a longer focal length with the camera held vertically, and leave out the stop

Rescue the original image

The only real option would be to crop the first shot vertically, cutting away the extraneous foliage and bridge parapet to the right and making the locomotive occupy a greater proportion of the frame as a whole. However, this would leave the stop sign on the left edge of the frame and the loco on the right, which would weaken the composition.

CHAPTER 5 SHUTTER SPEED

Shutter Speed

Definition: The amount of time the camera's shutter remains open to allow light to fall on the sensor or film. For any given exposure value (EV) the shutter speed has a direct relationship with the lens aperture.

It is almost certain that your camera will have Shutter Priority as one of its exposure modes. With this mode selected, you can select the desired shutter speed and the camera selects an appropriate aperture according to its meter reading. The camera may also select a suitable ISO setting, depending on how it is set up.

This is the mode to use when you want a very specific shutter speed in order to record subject movement in a particular way. This demands a greater degree of pre-visualization of the image compared to using Aperture Priority, which is considerably more forgiving.

Determining the precise shutter speed necessary is best learned from experience in different shooting situations and there simply isn't a list of recommendations for these. The reason for this is that the most important factor is the speed at which the subject travels across the frame, which means that sensor size, focal length, and framing all come into play. The greater the magnification of the subject within the frame, the faster the shutter speed needed to freeze the subject.

However, there are also different types of movement that you may encounter, and your subject may exhibit two or more of these at the same time. For example, when photographing a propeller-driven aircraft there is both the forward movement of the aircraft and, quite separately, the rotation of its propellers.

The common approach would be to use a shutter speed that is fast enough to freeze the aircraft's movement while still allowing the propellers to blur in order to create a sense of movement. Exactly the same principle applies to photographing racing cars or cycling, where the wheels will be rotating at a faster speed than the vehicle's forward motion. For these situations, choose a shutter speed of 1/500 sec. as a starting point and experiment from there.

FACTORS

Light available
Maximum/minimum shutter speed
Subject movement
Image stabilization
Aperture
ISO setting
Focal length

OWL IN FLIGHT

There is nothing more pleasing, at least to the author's eye, than capturing the graceful movement of birds and animals. This requires both an appropriate shutter speed and good timing. The author routinely uses a shutter speed of 1/2000 sec. for birds in flight.

Focal length: 300mm, Aperture: f/16, Shutter speed: 1/2000 sec., ISO: 3200

Waterfalls and fountains, however, would demand a very slow shutter speed if you wanted to create a soft white blur of water. This usually requires a shutter speed of around 1/2 sec., but practice will help you fine-tune your technique. With images such as these, the contrast between the moving water and its static surroundings can be quite important, so using a tripod may be better than image stabilization.

If neither your camera nor lens has any form of image stabilization, the shutter speed can also be selected to ensure that you avoid camera shake. The common guideline is that you need to select a shutter speed that is the reciprocal of the focal length in use: for example, 1/250 sec. for a 250mm focal length. This deals with the issue of the increased magnification created by longer focal lengths, but it does not account for additional factors that may create camera shake such as it being a windy day. When image stabilization is on offer, you can choose a slower shutter speed, but opt for 1 stop less adjustment than the manufacturer suggests, as they tend to be a bit optimistic.

RECORDING BLUR
A low ISO setting and a small aperture gave me a shutter speed of 1/2 sec., allowing the water to be transformed into a soft blur.

Focal length: 70mm, Aperture: f/22, Shutter speed: 1/2 sec., ISO: 100

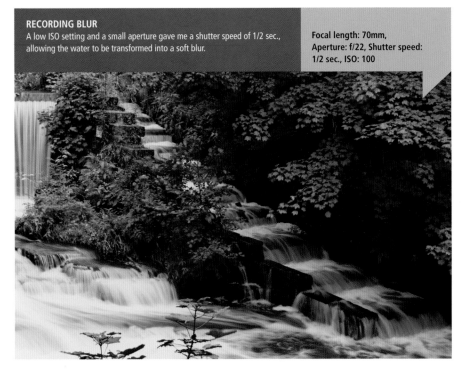

This general rule assumes that you are handholding the camera and lens without additional support. But, even if you do not have a tripod handy or it is inconvenient to use one, there are additional supports that can be made use of, and they don't have to be beneath the camera or lens. You can gain valuable stability by simply pressing the camera/lens combination against an upright post, for example, using a hat, handkerchief, or other soft material to cushion the camera or lens where it is in contact with the support.

Tip
When using shutter speeds faster than 1/500–1/1000 sec., turn off any image stabilization system. Above these shutter speeds the image stabilization system will almost certainly not resample fast enough to coordinate with the shutter, producing inconsistent and unpredictable results.

If your camera has a variety of *scene modes*, one of these could well be a Sports mode. This doesn't mean that it is only suitable for sports events; it just means that it is suited to capturing action, which can include anything that requires a fast shutter speed. This also makes such modes unsuitable when you want a slow shutter speed, so do not think of Sports mode as an "intelligent" version of Shutter Priority.

Note
Image stabilization is only useful for reducing camera shake. It does not replace the need for fast shutter speeds when you want to freeze subject movement.

Image stabilization
More and more lenses are being fitted with image stabilization systems, and an increasing number of cameras have similar systems built into the camera body itself. However, if you have both a camera and a lens with image stabilization, you can only make use of it on one of them: you cannot use both in combination, in an effort to double the benefits. Early stabilization systems offered only a 2-stop advantage, but more recent cameras and lenses have seen this increase to a 4-stop gain as the norm, meaning you can shoot at 1/15 sec. instead of 1/125 sec., for example. As a result, manufacturers continue to offer a lot of relatively slow zoom lenses that are made more usable in low light thanks to image stabilization, as well as being less expensive to manufacture and purchase.

Exposure Compensation and Bracketing

Whereas auto exposure bracketing (AEB) in Aperture Priority gives a sequence of shots captured at different shutter speeds, when AEB is dialled in with the camera set to Shutter Priority, the sequence of images is recorded at different aperture settings. If three shots are to be taken (some cameras offer more than this), the camera will take one shot at the exposure suggested by the meter, one at a wider aperture, and one at a smaller aperture. The gap or exposure increment between shots is normally one stop, but you may be able to change this to ½- or ⅓-stop increments (above right). As with aperture priority, exposure compensation can also be used on its own or in conjunction with auto exposure bracketing.

Timing

Another factor that affects the choice of shutter speed is the variation in speed of movement within the subject. Not all subjects move at a constant speed. When speed of movement varies—in some cases erratically, and in others the changes are more predictable—there will be brief moments when the movement is either slowed considerably or it may even halt momentarily. Such moments typically occur when a change of direction occurs.

In the golfing image shown opposite, the person playing the shot has been photographed at one of these brief moments in time, as his golf club was captured at the top of its swing. This has enabled a far slower shutter speed to be used, compared with that needed to freeze the rapid downswing of the golf club.

Tip

Most cameras that offer both exposure compensation and auto exposure bracketing will allow these two functions to be used simultaneously for additional control.

THE DECISIVE MOMENT

Choosing the precise moment when you trigger your camera's shutter can have an impact on the shutter speed required. Here, the shutter speed needed was far slower than it would have been if the golfer was on his downswing.

Focal length: 50mm,
Aperture: f/11, Shutter speed:
1/400 sec., ISO: 200

What went wrong?

Here we examine several images that display commonly encountered problems.

Shutter speed too slow

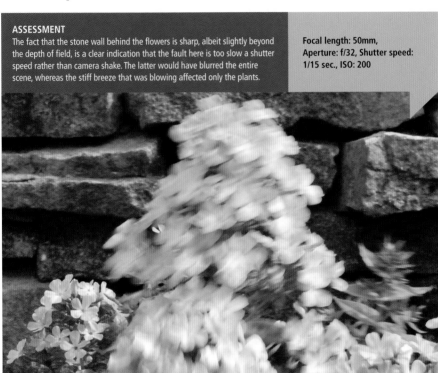

Solution

A two-fold solution is required here: both a higher shutter speed, say 1/250 sec., plus the patience to wait until there is a lull in the breeze and the flowers are not moving.

Alternative solution

Flash is a good way of stopping subject movement. Although the camera shutter's flash sync speed may not go beyond 1/250 sec., the duration of the flash is considerably faster than this.

Shutter speed too fast

ASSESSMENT
The most obvious point to make regarding this image is that this river in
spate has been "frozen" by too fast a shutter speed. It also suffers from some
camera shake.

Focal length: 70mm, Aperture: f/5
Shutter speed: 1/125 sec., ISO: 100

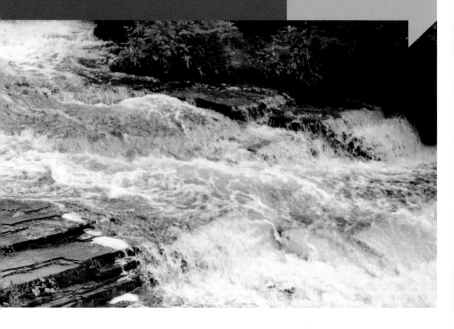

Alternative solution

This scene was actually quite dull, but in bright
conditions it is often necessary to use very low
ISO speeds, a very narrow aperture, and either
a neutral density or polarizing filter to force the
shutter speed down. A camera support is almost
always necessary, even when using image

Rescue the original image

I'm afraid there isn't anything that can be done
with this, other than learning the lesson.

SOLUTION

By using a shutter speed of just 1/4 sec., the water is nicely blurred and gives a far better sense of movement. The slow shutter speed also forced the need to find some support for the camera, which came in the form of a fence. Despite still being handheld, the foreground rocks and background foliage are actually sharper than the previous image.

Focal length: 70mm, Aperture: f/32, Shutter speed: 1/4 sec., ISO: 100

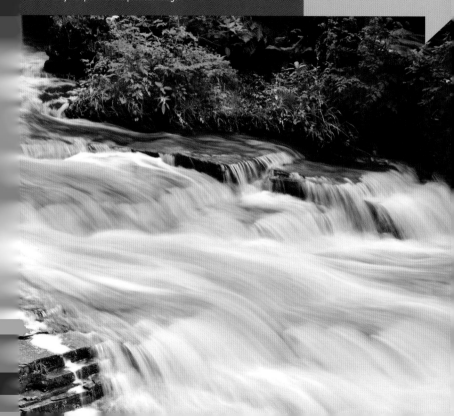

ASSESSMENT
A fast shutter speed and lens-based image stabilization have worked against each other here, resulting in a slightly blurred image.

Focal length: 280mm,
Aperture: f/5.6, Shutter speed:
1/500 sec., ISO: 200

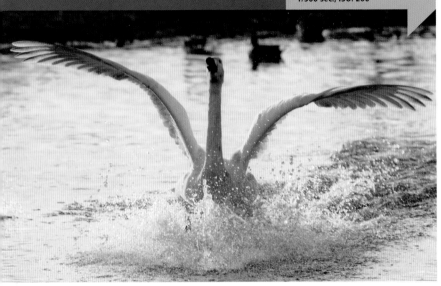

Assessment

Although slowing down, the swan was still traveling quite quickly. Despite using a 1/500 sec. shutter speed with lens-based image stabilization activated, the shutter speed simply wasn't fast enough. So why wasn't a faster shutter speed selected? Because, having chosen to use image stabilization, 1/500 sec. is about the fastest shutter speed that provides

resampling the image data being provided. The frequency with which this takes place means that, with shutter speeds shorter than 1/1000 sec. or 1/500 sec., the resampling may not be frequent enough to synchronize with the camera's focusing and exposure. In this case, the assumption that 1/500 sec. would be sufficient to freeze the subject's movement—while also allowing the image stabilization to

SOLUTION
Switching the image stabilizer function off and setting a shorter shutter speed
when shooting a fast-moving subject will often result in a sharper picture.

Focal length: 420mm,
Aperture: f/4, Shutter speed:
1/2000 sec., ISO: 200

Solution

When shooting a moving target that demands a fairly fast shutter speed, it can be better to switch off image stabilization and set a faster shutter speed instead. For birds in flight, the author regularly switches off image stabilization and uses shutter speeds of 1/2000–1/4000 sec. for birds with rapid wing beats.

The example above, of a charging goose, is a very similar situation to the previous image in so far as it shows a large bird approaching the camera position at speed. Here, however, a shutter speed of 1/2000 sec. was used with the lens-based image stabilization deactivated. With additional support from a fence, the result is a perfectly sharp image.

CHAPTER 6 ISO SPEED

ISO

Definition: The ISO speed is a measure of the recording medium's sensitivity to light and has a direct relationship with the combined values of shutter speed and aperture.

The ISO* speed is a rating applied to the sensitivity to light of the sensor or film. A higher number indicates a greater sensitivity, which means less exposure is needed—the exposure being a combination of the shutter speed and aperture. In short, low ISO speeds necessitate wider apertures and/or slower shutter speeds, while high ISO speeds permit smaller apertures (and therefore better depth of field) and/or faster shutter speeds.

The film user has to dial in the correct ISO setting on the camera for the specific film type being used, because this determines the processing times used by the lab for developing the film. If advised accordingly, the processing of the entire film can be adjusted if the film has been exposed at a different ISO than the one intended, whether intentionally or by accident. This is known as "push-processing" when the film has been exposed at too high an ISO setting, or "pull-processing" when the ISO has been set to a lower figure than intended by the film manufacturer. However, this usually degrades the final image to some degree.

Nevertheless, news photographers have often used push- (and pull-) processing to bring us images from remote parts of the world when they had to work with the only film stock they had at the time, even when it wasn't appropriate to the lighting conditions. So how does this differ from the ISO settings on a digital camera?

Whereas any processing adjustment in the lab would have to be applied to an entire roll of film, in digital photography we have the huge benefit of "processing" each image individually. An ISO speed of 6400 can be applied to one image, but the next could just as easily be shot at ISO 100.

*The standards adopted by the International Organization for Standardization (ISO) have replaced those used formerly by bodies such as the American Standards Association (ASA) and the German Institute for Standardization (DIN).

ISO MENU
The most common lowest native setting is ISO 100, often rising to ISO 6400 or higher. In this case, on a Canon EOS 7D, the native ISO can be expanded to 12,800.

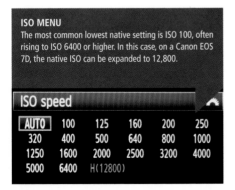

ISO speed					
AUTO	100	125	160	200	250
320	400	500	640	800	1000
1250	1600	2000	2500	3200	4000
5000	6400	H(12800)			

With increased ISO speeds using film, the final image is always subject to "grain," which arises from the chemicals used and especially the small clusters of light-sensitive silver halide crystals suspended in gelatine that together form the film emulsion. Whenever film is exposed at a higher ISO than was intended by the manufacturer, and processed accordingly, grain is likely to be more apparent.

Obviously, digital cameras do not use chemical processes, so the images do not suffer from grain. However, they do suffer from the digital equivalent, which is referred to as "noise." As with film, the higher the ISO, the more obvious this noise is in the final image, and it is also more prevalent if you underexpose an image (deliberately or unintentionally) and then try to rescue it in post-processing.

The present generation of DSLRs now commonly boast the ability to shoot at ISO speeds of ISO 12,800 or even ISO 25,600, with some professional cameras offering settings as high as ISO 102,400. Compare that with film, where even specialist films of ISO 3200 would be hard to track down.

Most DSLRs usually offer a set range, referred to as the "native" ISO, with the added ability to "expand" the highest setting and sometimes the lowest setting also. These menu-driven expanded ISO settings on a DSLR are not "native" to the camera, but are artificially created in much the same way as a lab can adjust the processing for a film that has been exposed at the wrong settings. As a result, the final images are disproportionately subject to more noise than those taken with a native ISO setting.

When ISO settings are increased on a digital camera, the electrical signals produced by the individual picture elements on the sensor are amplified. Unfortunately, unwelcome additional electrical signals—that are well controlled at low ISO speeds—are also magnified, and it is these that produce the "noise" in the final image.

The higher the ISO setting the more this is evident, especially when ISO settings exceed their native boundaries.

Noise exists in two forms: luminance noise, which looks similar to film grain, and chrominance (color) noise, which appears as colored speckles. The latter can be seen clearly in the image below, even in the white wall.

Ultimately, dealing with noise is a trade off between the quality of the final image and the importance of the subject matter. When the subject is of absolute importance, image quality—though desirable—can be ignored: witness the appalling footage shot on cell phones on the television news when a disaster occurs, for example.

Camera settings

Your DSLR will almost certainly offer the facility of an auto ISO setting, regardless of the exposure mode, but the ability to override this may only be available in Aperture Priority, Shutter Priority, Program, and Manual exposure modes. In the increasingly common scene modes, which tend to be largely automated, you may not be able to set a specific ISO.

The automation of ISO setting can be extremely useful, provided you can determine a "ceiling" for the highest setting. This is still not a common facility, but is being included increasingly on cameras at all price levels. When an ISO ceiling (a user-set maximum ISO) is selected, you can determine an exact aperture and an exact shutter speed in manual exposure mode, leaving the camera to vary just the ISO setting in line with variations in meter readings. It will do this without the risk of the camera setting an ISO that results in unacceptable noise levels. This means that you can set the ISO ceiling in line with the individual camera's characteristics. For example, the author regularly uses this feature with an ISO ceiling of ISO 1600 on his Nikon D3s, due to its high ISO performance, when on previous cameras a maximum of ISO 400 would have been used.

HIGH ISO NOISE
Taken at ISO 6400, chrominance noise is clearly seen in this detail from the image on the previous page.

Another feature frequently found is ISO expansion. This is when the camera's native ISO range can be exceeded, at either the low end or the top end of the range, or both. Different manufacturers use different setting indicators, but you can expect the ISO reading in the viewfinder or on the LCD screen to read L or L1 for a low setting and H or H1 for a high setting, instead of the usual numerical ISO indicator. These can be useful when both the lighting conditions and the importance of the photo demand it. However, it is suggested that ISO expansion is not used as part of your normal exposure strategy as image quality is noticeably reduced. This is fairly obvious—if the manufacturers felt that image quality was good enough to be considered "normal," these expanded settings would form part of the native ISO range.

With manufacturers making consistent improvements in noise levels at higher ISO settings, it is surprising that ISO bracketing has not made a reappearance. This was a feature that Canon included on several of its professional cameras several years ago, then dropped. This was a form of auto exposure bracketing that varied the ISO rather than the aperture or shutter speed.

Noise reduction

Image noise is exacerbated by a number of factors, the two most common being very high ISO settings and/or very long exposures (measured in seconds rather than fractions of a second). You may find that your camera offers noise reduction in its menu system to counter this, either offering a single noise reduction option, or a choice of both high ISO noise reduction and long exposure noise reduction. In-camera noise reduction can often be set at different strengths: typically off, low, medium, and high. Image noise is also more evident when images are underexposed and then corrected during post-processing—the greater the exposure recovery, the greater the noise.

Noise appears in two forms (chrominance noise as unsightly colored speckles and luminance noise as a granular texture) and both require different treatments to reduce their appearance. When noise reduction is applied to luminance noise it is achieved by gently blurring the image, so a loss of sharpness is encountered. Because of this, it is better to start by reducing chrominance (color) noise first and then apply only a minimal amount of luminance noise reduction to preserve sharpness.

Tip
To apply long exposure noise reduction, the camera records a second, "black," frame with the shutter closed, for comparison. This second exposure will take as long to record as the initial exposure, which means it can slow down shooting dramatically in some situations, especially if you are using a memory card with a slow write-speed.

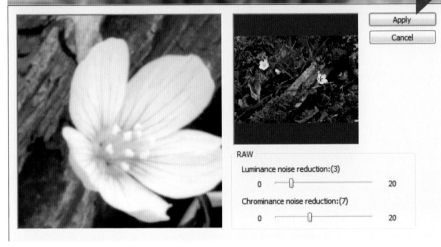

NOISE REDUCTION
Reducing the amount of noise in an image requires care and attention if you want to retain all of the detail. Noise reduction is best applied to the chrominance (color) noise first, with only a minimum amount of luminosity reduction applied after this.

NR Preview

Apply

Cancel

RAW
Luminance noise reduction: (3)
0 20
Chrominance noise reduction: (7)
0 20

Film simulation

While discussing digital image noise and film grain, this seems an appropriate place to explore the post-processing options provided by film simulation software. Software such as Alien Skin Software's Exposure 3 provides Photoshop plug-ins that allow the user to simulate a very wide range of different films.

Applied via Photoshop's filter menu, these effects can mimic not only film grain, but also the color and sharpness associated with the selected film type. Many different films are represented—dating back decades in some cases—and the list includes unusual film types such as black-and-white infrared.

MOORLAND CAIRN
This image was adjusted in Photoshop using Alien Skin Software's Exposure 3 plug-in and treated to a simulation of Kodachrome 25, a film long associated with biting sharpness and excellent color.

Focal length: 20mm, Aperture: f/11, Shutter speed: 1/250 sec., ISO: 200

What went wrong?

Here we examine several images that display commonly encountered problems.

Noise at high ISO

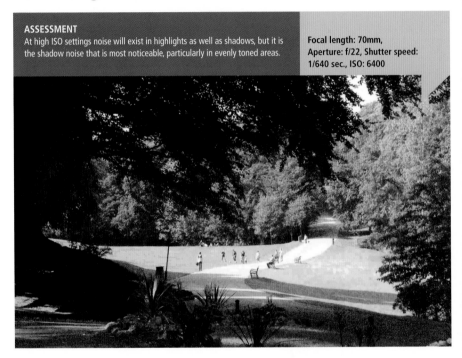

Solution

A setting of 6400 ISO wasn't necessary for this shot, although a fairly small aperture was needed for the depth of field required. Bringing the ISO down to ISO 1600 would have increased the shutter speed to 1/160 sec., but this is still sufficient to avoid camera shake with a 70mm focal length.

Alternative solution

With a stabilized lens, up to 4 stops could have been gained—perhaps 1 stop on the aperture and 2 or 3 stops on the shutter speed—which could have reduced the ISO to just ISO 200 or possibly even ISO 100.

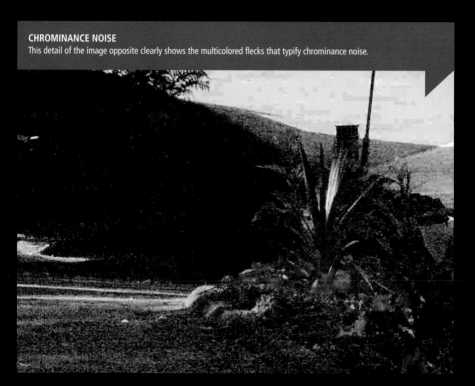

CHROMINANCE NOISE
This detail of the image opposite clearly shows the multicolored flecks that typify chrominance noise.

Rescue the original image
Some noise reduction, combined with highlight/
shadow balance, should be possible even if the
image is shot as a JPEG. If offered the choice of
luminance noise reduction or chrominance noise
reduction, the chrominance setting will deal
better with the multicolored pixels.

Low contrast

ASSESSMENT

Setting a high ISO might seem like the answer to everything, especially when light levels are low, as it will allow a faster shutter speed to be used to avoid camera shake and/or a smaller aperture to give a greater depth of field. But, as always with exposure, there is a trade-off. Along with a high ISO setting comes more noise, reduced apparent sharpness, and lower contrast. In this instance the bright yellow flowers add some "punch" to the image, but the inscription on the memorial clearly shows just how little contrast there really is.

Focal length: 135mm, Aperture: f/16, Shutter speed: 1/400 sec., ISO: 6400

Solution

An aperture of f/16 really wasn't necessary, and f/8 would probably have sufficed if focus had been on the flowers immediately in front of the memorial stone. Additionally, a shutter speed of 1/200 sec. would easily have been fast enough to avoid camera shake using a focal length of 135mm. That amounts to a saving of 3 stops, so an ISO setting of ISO 800 could have been used instead of ISO 6400.

Alternative solution

Fill flash could have provided a solution here, but the flash illumination would not have reached the foliage in the background.

CHAPTER 7 DYNAMIC RANGE

Dynamic range

Definition: The spread of tones in an image, from light to dark, within which detail can be recorded.

While digital images can record a far wider range of tones than, say, transparency (slide) film, they still fall short of the range that the human eye can distinguish. As a result, our images don't always come out the way we expect.

The dynamic range is the spread of tones within which detail can be recorded from the lightest highlights through to the deepest shadows, from almost white to almost black. The top of the dynamic range is reached when a pixel records the brightest tone possible without being pure white. At the opposite end of the scale the reverse is true, with a pixel recording detail just short of being black. If the tones exceed this range then detail will be lost, either in the highlights, in the shadows, or in both areas. This loss of detail is referred to as "clipping" and, as a result, the photographer is usually faced with three options:

- Expose to preserve the highlights and allow the deepest shadow tones to merge
- Expose to preserve the shadows and allow the highlights to burn out
- Aim for an exposure between the two extremes and allow both to be clipped, but to a lesser degree

The choice of which part of the tonal range to favor is usually determined by the intended end product. For instance, when producing images for magazine or book use, the quality of the paper to be used by the publisher can play a major part. Photographs solely for screen display, on the other hand, present fewer problems as they don't depend on reflected light and can usually harness a wider range of tones. If generating a photographic print then the choice of paper will again play a huge role.

Light balancing systems

Auto Lighting Optimizer (Canon), Active D-Lighting (Nikon), and D-Range Optimizer (Sony) all provide ways of balancing the brightness and tonal gradation within an image at the time of capture. Some can also be applied to RAW images after capture, with the aim of restoring detail to the shadows and highlights. Although each of these dynamic range tools were intended to be applied in high contrast shooting scenarios, they can also re-balance an image when part of the subject matter is darker than you would wish, for reasons other than the prevailing light.

They are perhaps best thought of as the simplest digital equivalent to Ansel Adams's exposure and film processing techniques referred to later in the chapter, with digital HDR processing being a more sophisticated and user-controlled approach.

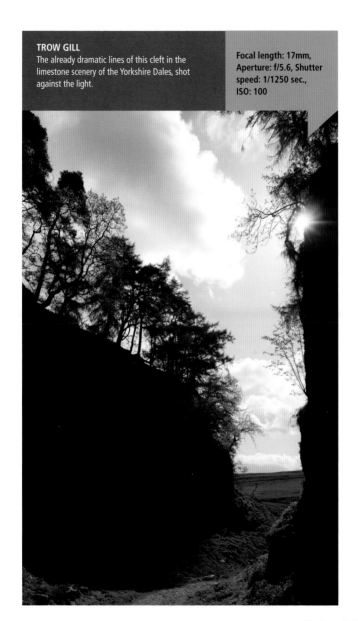

TROW GILL
The already dramatic lines of this cleft in the limestone scenery of the Yorkshire Dales, shot against the light.

Focal length: 17mm, Aperture: f/5.6, Shutter speed: 1/1250 sec., ISO: 100

Highlight tone priority

This is a function introduced by Canon that improves highlight detail by smoothing the transition between the lightest tonal values. As it applies only to the top half of the dynamic range—between the midtone (18% gray) and the highlights—some shadow noise may result, and the ISO range will be restricted when this mode is activated.

Tip
When using a light-balancing system it is best to use a matrix or full-frame evaluative metering mode. You should also be aware that, when combined with a high ISO setting, noise may be increased in some parts of the image and that the time taken to record the image will increase, regardless of the ISO.

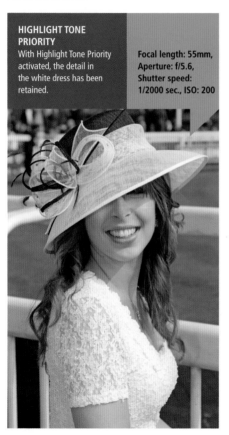

HIGHLIGHT TONE PRIORITY
With Highlight Tone Priority activated, the detail in the white dress has been retained.

Focal length: 55mm,
Aperture: f/5.6,
Shutter speed:
1/2000 sec., ISO: 200

Color versus black and white

On the face of it, capturing an image for black-and-white use should be much the same as capturing color, but there are different considerations. Color relies heavily on… well, color… for its impact, as well as subject matter and composition, whereas black and white (also known as monochrome) relies rather more heavily on the subject matter and dynamic range. Composing a monochrome image can also be quite different, as you are looking to distribute tone throughout the image in a way that doesn't apply to color photographs.

Metering for black and white is different too. Color works best within a narrower exposure range than black-and-white images, making the midtone crucial; it is quite common, though hardly desirable, to allow shadows to block up and highlights to burn out. By comparison, it is necessary to ensure that the tonal range in a monochrome image, except in "high key" images, only just reaches the white point and provides a full range of tones right down to black. In effect this means that,

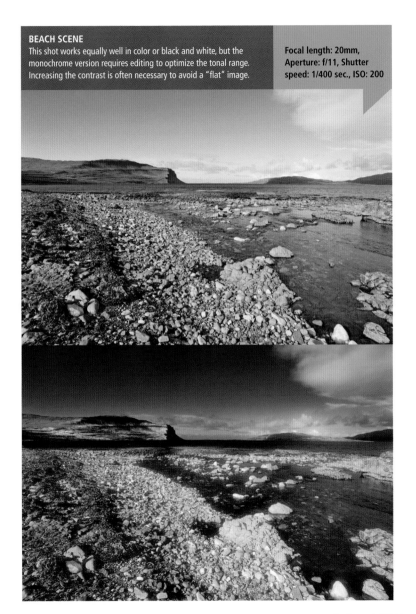

BEACH SCENE
This shot works equally well in color or black and white, but the monochrome version requires editing to optimize the tonal range. Increasing the contrast is often necessary to avoid a "flat" image.

Focal length: 20mm, Aperture: f/11, Shutter speed: 1/400 sec., ISO: 200

given two versions of the same scene, an ideally exposed color image and an ideally exposed monochrome image will be different, with the mono image being tonally richer than the color version and darker overall. The mono image will also benefit from slightly greater contrast, as color images rely on a combination of both tonal contrast and color contrast for effect.

Skies are often important to a black-and-white image. A lovely blue sky is a blessing for travel and scenic photography, but when shooting black and white it is necessary to look for interesting cloud formations, because a blue sky devoid of cloud in black and white is just a large expanse of gray.

With landscape scenes this focus on the sky can also affect one of the most crucial decisions regarding composition—at what height in the frame to position the horizon, as shown in the example below.

INCH KENNETH
This tiny island off the west coast of Scotland, together with the approaching weather system, just begged for the unconventional positioning of the horizon very low in the frame.

Focal length: 140mm, Aperture: f/5.6, Shutter speed: 1/2000 sec., ISO: 200

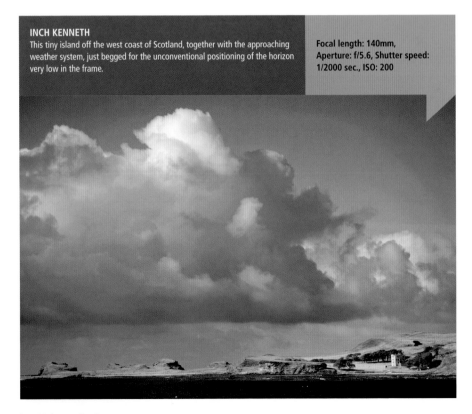

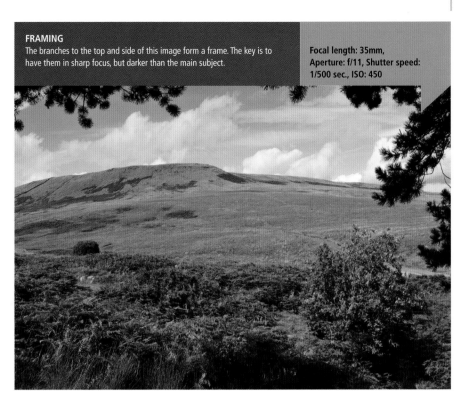

FRAMING
The branches to the top and side of this image form a frame. The key is to have them in sharp focus, but darker than the main subject.

Focal length: 35mm,
Aperture: f/11, Shutter speed: 1/500 sec., ISO: 450

Foreground frames

Books and articles on composition frequently suggest using the foreground to create a "frame" for the main subject, and this can work well if the frame is virtually in silhouette, providing it has an interesting shape; color and texture are irrelevant if this technique is used.

For this to happen, the foreground needs to be receiving less illumination than the scene being captured and the exposure should be determined by the main subject matter excluding any influence the silhouetted foreground might have. In other words, it may be better not to use any form of matrix or evaluative metering that takes the whole image area into account.

Finally, a fairly small aperture needs to be used with a standard lens (or a moderate aperture with a wideangle focal length), in conjunction with focusing at the hyperfocal distance, or at least using the depth of field preview function to ensure that the foreground frame is also in focus.

Neutral density filters

There are occasions when there is simply too much available light. The most common scenario is when you want a very slow shutter speed in order to create blur—when photographing a waterfall, for example. In these circumstances a neutral density filter, which reduces the amount of light passing through the lens, is a great aid. Theoretically, ND filters should not affect the color balance, but the reality is that some of them do, particularly resin ones, which can have a gray tinge to them. These filters come in a range of strengths and are generally available in 1–4 stop versions as both screw-in glass filters and rectangular resin varieties. Strength may be indicated as ND2 for one stop, ND4 for two stops, and so on, or ND0.3 for one stop, ND0.6 for two stops, with ND0.45 being 1½ stops.

Graduated neutral density filters

Second only to a polarizing filter in terms of importance in the landscape photographer's tool kit, graduated ND filters are used to balance exposure in different areas of the image. These filters are half clear with the other half having a neutral density coating that is increasingly dense as it approaches the outer edge of the filter.

Graduated ND filters are used to balance the exposure in different areas of the image and rectangular filter systems are the most flexible option. You can vary the effect by the amount you slide the filter into the holder, plus you can insert a filter upside down to darken the bottom of the image. Furthermore, if you "piggy back" two filter holders you can rotate one of them to darken a corner of the image.

Graduated ND filters are available in various strengths, with differing transitions between the clear area and the edge of the neutral density coating: soft, hard, or razor. Hard and razor gradations are useful when you have a flat horizon, such as with a seascape, while a soft gradation is better suited to irregular horizons.

Tips
One advantage of rectangular filter systems is that you can fit several filters into the holder. More importantly, when using graduated ND filters you can fit a second filter holder that will rotate to any angle. With this combination you could have one ND grad filtering the whole sky area, another upside down filtering a bright foreground object, and a third at an angle darkening just a corner of the image, with each filter making use of different strengths (and transitions) according to the lighting and the scene.

It is important to note that a filter's designation, in terms of strength, relates to the maximum light reduction at the outer edge. For this reason, people buying their first graduated ND filter sometimes buy a weaker strength than they require. If purchasing a rectangular type, there is no harm in buying one that is stronger than you think you may need, as you can always slide it up in the filter holder to reduce its effect.

GRITSTONE OUTCROP

A graduated neutral density filter has been used in this landscape shot to make sure that the exposure for the sky balances that of the foreground—without it, the sky would likely be overexposed.

Focal length: 35mm, Aperture: f/8, Shutter speed: 1/250 sec., ISO: 200

CREEPER
A polarizing filter would have reduced the glare from the leaves and this would also help boost the color saturation.

Focal length: 35mm, Aperture: f/11, Shutter speed: 1/160 sec., ISO: 200

Polarizing filters

If you don't have an ND filter, you can use a polarizing filter instead, to reduce the exposure value by around two stops across the image. Polarizing filters are generally used to reduce reflections or to boost blue skies with fluffy white clouds. However, they also reduce light being reflected from foliage, so they can really add strength to green foliage in particular.

This study of a section of wall draped with colorful Virginia creeper in late summer (above) suffers a little from glare on a bright sunny afternoon and would have benefited from a polarizing filter to reduce the reflected light from the leaves and boost the color as well.

Contrast

In scenes such as the one illustrated opposite, the maximum possible range of tones is

represented. In fact, both the darkest and brightest parts of the image are quite close to its center, making the risk of incorrect exposure even greater. This would be an ideal situation to try spotmetering. Ask yourself the question: what part of the image would I expect to render a midtone if I were spotmetering? Probably the best area would be the well-illuminated area of greenery a couple of feet to the right (as we look at it) of the base of the door frame.

Tip
If in doubt, err on the side of underexposure. Once the highlights in an image have blown it is virtually impossible to extract detail from them during post-processing. Shadow detail, however, is easier to reveal, albeit with the risk of increased noise.

COTTAGE DOOR
When the brightest and darkest parts of the image are close to each other, as here, spotmetering will help avoid the risk of incorrect exposure.

Focal length: 55mm, Aperture: f/11, Shutter speed: 1/320 sec., ISO: 200

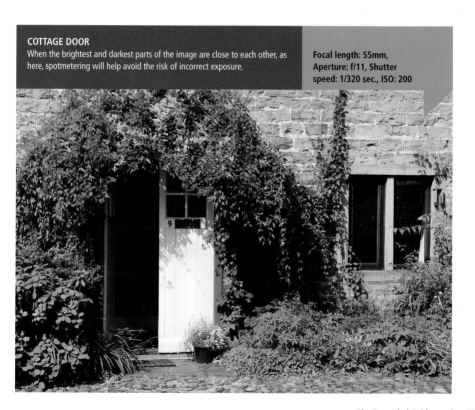

Zone system

This is probably a good point to introduce a very brief explanation of the zone system. This was perfected by Ansel Adams, a landscape photographer renowned for his stunning black-and-white prints, one of which recently fetched over $700,000 at auction—so he must have been doing something right!

Adams defined a ten-zone scale, ranging from 0-X using Roman numerals. At the bottom of the scale is pure black (Zone 0) and at the top is pure white (Zone X). Zone V represents the mid-point. He went on to identify some of the image qualities that could be expected from each of these tones, identifying tonal and textural detail where appropriate.

It is important to understand that there are very real differences between the work of Ansel Adams and the images that most of us are trying to achieve. He was working with large plate cameras, producing single negatives with the finest gradation of tones, and he was aiming for very large photographic prints as his end result.

What's more, the zone system was designed to capture scenes in which the tonal range exceeded the capacity of both his negatives and his printing materials. Yet by overexposing and under-developing the film as well as careful metering he produced tonally perfect prints. Nevertheless, the basic principles can still help us make the best use of spotmetering.

High dynamic range

Increasingly popular of late with photographers willing to explore new territory, high dynamic range (HDR) photography might claim to be the digital equivalent of what Adams succeeded in doing. The basic principle is as follows: the photographer takes several shots of the subject at different exposures, which are then combined into a single image. This avoids the likelihood of adding noise or incorrect color rendition from trying to squeeze detail out of a single image.

There is no reason why the metering and exposure processes should not be carried out in as meticulous a fashion as was applied to the Zone System, but many users simply rattle off a bracketed series of exposures as the basis for HDR conversion.

A recently published Canon patent application explores a mechanism for altering exposure values at pixel level that would allow the manufacture of a camera that captures a wide dynamic range in a single image. Although not all patent applications result in new products, this is perhaps a sign of things to come and when coupled with an ultra high-resolution sensor it would be of great interest to studio and landscape photographers.

Tip

For those who already use Photoshop or other software in which tonal values are expressed numerically on a scale of 0–255, these are the values that equate with the Zone System:

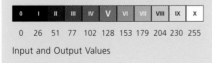

0	I	II	III	IV	V	VI	VII	VIII	IX	X
0	26	51	77	102	128	153	179	204	230	255

Input and Output Values

THE ZONE SYSTEM

Zone 0: Pure black
Zone I: Near black with slight tonality but no texture
Zone II: Textured black—the darkest part of the image in which any detail can be discerned
Zone III: Average dark material and shadow, or other low tonal values in which texture is clearly visible
Zone IV: Average dark foliage, dark rock/stone, or shadows in the landscape
Zone V: Mid-gray, equal to a clear north sky;

also equal to dark skin and weathered timber
Zone VI: Equal to average Caucasian skin tones; also equal to light rock/stone and to shadows on snow in sunlit landscapes
Zone VII: Very pale skin tones; also shadows in snow with acute side-lighting
Zone VIII: The lightest tones that will retain any discernible texture; textured snow
Zone IX: The palest of tones before white; no texture visible; bright snow
Zone X: Pure white

Creating an HDR image

The first stage is to take a series of exposures of the same subject. Below, five exposures are shown covering a 5-stop range from +2 stops to -2 stops. All of these are loaded into the HDR software which creates a base image (opposite, top) that is then tone-mapped to produce a single high dynamic range picture. With the software used in this example (Photomatix Pro 4.0) a range of different preset outcomes are offered and shown as thumbnails. Any one of these can be selected as the new base image, which can then be adjusted further using the controls shown at the left of the screen.

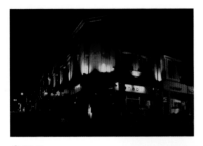

-2 stops

-1 stop

Metered exposure

+1 stop

+2 stops

The range of tools available for adjusting an HDR image will depend on the software used, but you can expect a wide range that will encompass the adjustment of the midtones, highlights, and shadows and, most importantly, the setting of the white point and the black point—the two opposing ends of the dynamic range. With this particular piece of software, three different HDR approaches are taken to generate a variety of preset outcomes: enhanced, compressed, and fused. Enhanced images focus on smooth transitions and the retention of detail, while compressed images reduce the tonal range to produce stronger, more saturated images. Fused images provide a blend of the two.

The number of original bracketed images which can be processed may also vary. It is quite common to use five images, each 1 stop apart, but you could use just three, or possibly seven or more. The greater the number of bracketed images, the smoother the final result will be. It isn't necessary to use an odd number of exposures either, although this is the most logical course of action; nor is it necessary to use 1-stop increments. You may start out intending to use five images, but with some experimentation find that the darker four exposures provide the best result.

Once your HDR adjustments have been completed, the image can be processed and saved. After this, you can treat the image as you would any other, making further changes in Photoshop or your preferred software. For example, in the final image (opposite) the image has been cropped slightly and the

converging verticals on the right (notably the traffic lights and the chimney stack) have been corrected using the Force Parallel tool in DxO Optics Pro 6.0.

Tips
At first, HDR software was designed to work with separate exposures, all created in-camera. However, it is now quite common for HDR software to be able to work successfully with a series of images created from a single RAW file, each one simulating a different exposure.

One of the issues that is raised by bracketing in-camera is the slight movement of elements within the image, such as clouds or traffic, which would be in a fractionally different position in each separate image. Creating an HDR image from a single file eliminates the difficulties encountered in achieving the precise alignment of moving subjects.

This is the original image at the center of the five bracketed exposures: the optimum exposure suggested by the camera's meter. Both highlights and shadows have been clipped noticeably. Compare this with the HDR-processed image below.

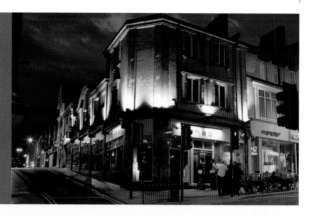

The final image. Note how much more detail can be seen in the sky and in the shadow areas, especially along the side street to the left of the image.

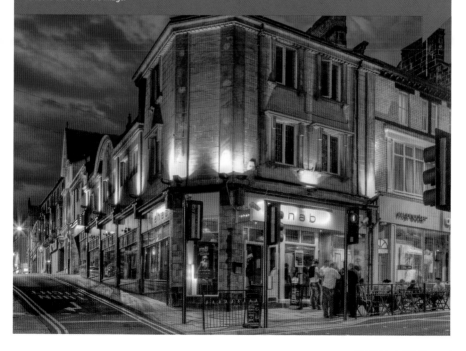

What went wrong?

Here we examine several images that display commonly encountered problems.

Clipped shadow detail

ASSESSMENT
While the exposure as a whole is clearly correct for the sunlit stone wall and hedge, the main subject is largely devoid of detail as it has been thrown into shadow. In this case, this is a result of nothing more than poor timing.

Focal length: 28mm, Aperture: f/5.6
Shutter speed: 1/320 sec., ISO: 100

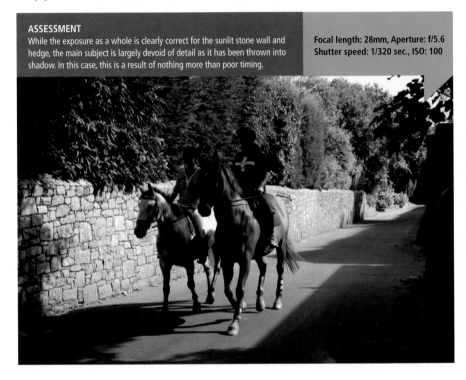

Solution

Forethought, preparedness, and the ability to select a suitable viewpoint would have helped enormously here, enabling me to capture the two riders when they were more evenly lit.

Alternative solution

Use a higher ISO for reduced contrast, or in-camera image adjustment such as Canon's Auto Lighting Optimizer, Nikon's Active D-Lighting, or Sony's D-Range Optimizer to reveal more shadow detail. it would also be possible to shoot this scene for an HDR treatment.

The two riders could be brought out of the shadows by judicious adjustment of the contrast, shadows, and highlights, but the cost of this is an overexposed stone wall, so cropping becomes necessary. The example shown below is the result of these adjustments with added manipulation using the HDR tool in DxO Optics Pro 6.

Clipped highlight detail

Solution

The first part of the solution is to take a meter reading of the scene outside and use this as the basis for the scene to be captured inside. Inevitably, this will leave the interior underexposed, so the second part of the solution is to use flash, setting the flash exposure to match the outside meter reading. Test shots are advisable to see if any flash exposure compensation is necessary.

Alternative solution

Rearrange the subject or your own position so that the windows are out of shot or are blocked by something in the foreground.

Rescue the original image

With the key figure central to the area of the image that exhibits the greatest problem, options are restricted to reducing the brightness of the highlights. The end result would still fall far short of a properly exposed original that balanced both the interior and exterior lighting using flash.

ND filter needed

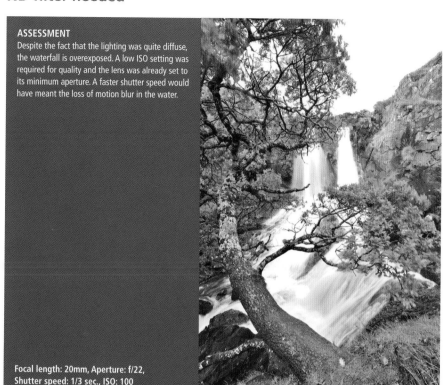

ASSESSMENT
Despite the fact that the lighting was quite diffuse, the waterfall is overexposed. A low ISO setting was required for quality and the lens was already set to its minimum aperture. A faster shutter speed would have meant the loss of motion blur in the water.

Focal length: 20mm, Aperture: f/22, Shutter speed: 1/3 sec., ISO: 100

Solution

What was needed here was a neutral density filter to give a couple of stops more flexibility.

Alternative solution

A polarizing filter would have provided the same effect on exposure as a 2-stop ND filter, allowing the exposure to be reduced.

Rescue the original image

Some work has already been done on the image in post-processing to darken the highlights, but—other than when reproduced quite small, as here—it would be improved more by exposing correctly to start with.

Graduated ND filter needed

ASSESSMENT
This interesting scene on the foreshore of Hastings, an ancient fishing port on England's south coast, features the tall sheds used for drying fishing nets. There is nothing wrong with the exposure as such, but the sky is washed out, especially to the left. This is important if the image is to be displayed on a white background as the two will merge.

Focal length: 28mm,
Aperture: f/5.6, Shutter speed: 1/1000 sec., ISO: 200

Solution

The image would have benefited from the use of a graduated ND filter to darken the sky and give it a solid color. The extent to which this would happen is dependent on the strength of the filter.

Alternative solution

High dynamic range software could bring out the missing detail in the sky without sacrificing detail elsewhere.

RESCUE THE ORIGINAL IMAGE

Some adjustment in post-processing can be achieved, providing detail in the sky is recorded when the image was captured. In such situations it is better to deliberately underexpose by a stop to ensure that highlight detail is captured.

CHAPTER 8 IMAGE ADJUSTMENTS

Image Adjustments

Definition: This term has been used here to describe settings that affect the image quality and characteristics, although not necessarily the fundamental exposure.

Image adjustments fall into two broad categories: those that can be applied prior to shooting, and those that are applied after capture (the latter sometimes depending on whether the image is a JPEG or RAW file). No differentiation has been made between the two types because there is an increasing trend to include post-capture adjustments in-camera, so some readers will have this option for a specific adjustment and others won't. There are also so many different adjustments—called one thing by one manufacturer and something else by another—that we will concentrate solely on the most commonly encountered adjustments.

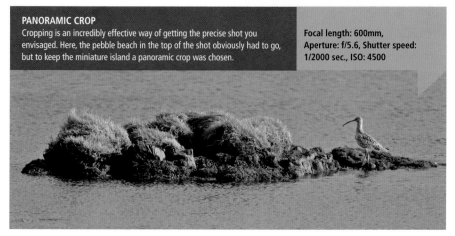

PANORAMIC CROP
Cropping is an incredibly effective way of getting the precise shot you envisaged. Here, the pebble beach in the top of the shot obviously had to go, but to keep the miniature island a panoramic crop was chosen.

Focal length: 600mm, Aperture: f/5.6, Shutter speed: 1/2000 sec., ISO: 4500

Cropping

It may come as a surprise that this has been selected to come first in this chapter, but effective cropping is an incredibly important skill. There are times when you simply won't notice elements that may detract from the final image, and there are also times when you won't have the reach with the lens on the camera at the time of shooting to get the picture you are after. The image opposite demonstrates not only this, but also the limitations of a fixed image ratio, in this instance the 3:2 ratio of a full-frame sensor.

One of the best ways of learning to crop images effectively—after they have been recorded—is to equip yourself with two L-shaped pieces of black card, each about 4cm in width and at least 18cm long on the longer edge. With an image on your computer screen, displayed at roughly the same width as the longest edge of your card, you can move the two pieces of card around to find the most pleasing crop, as shown below. A similar technique can be used in the field to select your composition at the time of shooting.

CROPPING TOOL

This is the cropping tool in Canon's Digital Photo Professional (DPP) software. All image-editing programs will feature a similar tool, allowing you to crop to pre-defined sizes or ratios, as well as setting the crop area manually.

Tip

If you shoot RAW files, then cropping done in your RAW conversion software is likely to be applied to the image only when it is converted into a JPEG or TIFF. This means you can re-open the original RAW file at any time and re-crop it if you choose to.

CANON Picture Styles

Canon's Picture Styles are well established, providing six different groups of settings, each of which can be adjusted from the default. In addition, some camera models permit User Defined styles based on one of the presets. There is little difference between Standard, Neutral, and Faithful, although Neutral provides the flattest-looking (lowest contrast) image. Portrait provides a slightly warmer image, with the sharpness reduced slightly to soften wrinkles and skin blemishes. Landscape provides rich greens and blues—so much so that use of a polarizing filter almost needs to be discouraged. Within each of these Picture Styles, the sharpness, contrast, saturation, and color tone, can be modified.

The final Picture Style is Monochrome. This is fairly self-explanatory, but saturation and color tone are replaced with filter and toning options. The different filter effects attempt to mimic the yellow, orange, red, and green filters used with black-and-white film, while the toning options provide sepia, blue, purple, or green tints.

At first glance, these Picture Styles seem relatively straightforward, but Canon has also included some additional preset-processing to some of these, which aren't obvious from the adjustable parameters. The Landscape Picture Style, for example, attempts to bring out detail in the shadow areas, in addition to boosting the color saturation.

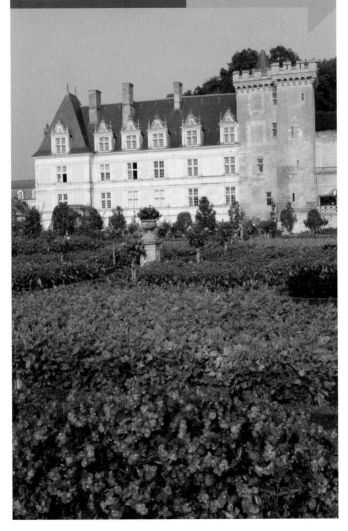

FRENCH CHATEAU
Neutral (below) and Landscape (opposite) Picture Styles from Canon: The differences are obvious.

Focal length: 28mm, Aperture: f/11, Shutter speed: 1/100 sec., ISO: 100

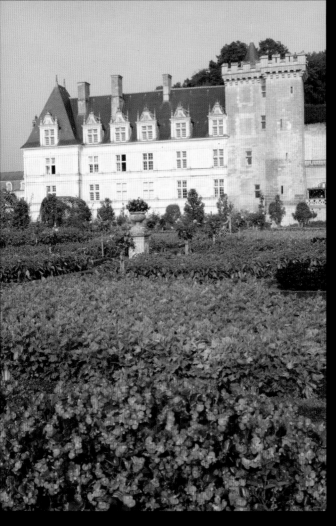

NIKON Picture Controls

Nikon's Picture Control system adopts a similar approach to that of Canon, although there are some important differences. The six Nikon presets are Standard, Neutral, Vivid, Landscape, Portrait, and Monochrome. The big difference here is the Vivid style, which appears far more saturated than any of Canon's options. However, the Landscape option isn't quite as saturated as Canon's equivalent, and it doesn't open up the shadow areas in the same way.

Nikon's parameters for each of these presets include sharpening, contrast, brightness, saturation, and hue. However, if Active D-Lighting is activated, the ability to adjust the contrast and brightness is disabled as this would conflict with the optimization process. The Monochrome options also mirror Canon's settings, although there is a far greater range of toning options.

As for Nikon's Neutral setting, if you compare this image with Canon's version

SAWLEY ABBEY
Nikon's Neutral preset (below) and its Vivid setting (opposite), the latter after slight adjustment. Nikon's Landscape Picture Control is not an exact match for Canon's Landscape Picture Style, which produces slightly more saturation.

Focal length: 18mm, Aperture: f/8, Shutter speed: 1/640 sec., ISO: 200

of Neutral on the previous pages, you will see that the photograph taken with a Nikon camera is much stronger in terms of its color saturation. This highlights one of the many reasons why swapping from one camera system to another is a major issue. It is not simply a new camera layout and different lens options that you have

to adapt to, but also the creative image controls. If you have developed an approach to your digital workflow that gives you results you are happy with using one particular manufacturer's products, then it can take some time configuring a different manufacturer's camera so that it produces comparable results.

In addition to Canon's Picture Styles and Nikon's Picture Controls, other manufacturers also provide similar settings. Sony's Creative Style settings offer Standard, Vivid, Neutral, Portrait, and Landscape modes, as well as additional options in the form of Clear (limpid colors in highlights, suitable for capturing radiant light), Deep (for dense deep colors), Light (for a "refreshingly light ambience"), Sunset, Night View, and Autumn.

Tips
Your camera's RAW software may make it possible to change a picture style and its parameters during post-processing.

If selecting a picture style in-camera prior to shooting, it is usually better to select it before commencing metering.

Color space

The majority of DSLR cameras allow the user to choose a color space. This is the term used throughout the photography and publishing industries to describe the range—known as the "gamut"—of colors available for reproduction. This includes the numeric values that represent these colors in a digital image file and the in-camera options will be either sRGB or Adobe RGB color spaces.

Of the two options, sRGB is more widely used, whereas Adobe RGB tends to be favored for publishing and commercial printing. Camera manufacturers suggest using the sRGB color space for images that will be printed without modification, or for viewing them in software applications that do not support color management. The sRGB color space is also recommended if you intend to print images using ExifPrint or direct printing from your memory card, whether at home or using commercial "kiosk" printing services, as well as to an inkjet printer. While Adobe RGB can

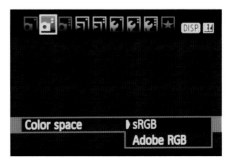

also be used for printing in these situations, the colors may not appear as strong.

Screen calibration

Before manipulating images on your computer, ensure that your monitor is calibrated for brightness, contrast, and color using dedicated software or graphics freely available on the internet. You should be able to discern a good range of tones from pure black to pure white. If the dark gray tones blend into black, the screen is too dark. If the light gray tones blend into white, the screen is too bright.

Typical color calibration image
(courtesy of Digital Masters)

Brightness versus contrast

Brightness and contrast go hand in hand, with a change to one often requiring a subsequent change to the other. However, it is important to consider the impact of changes on the background, as well as on the main subject.

In the image below, a balance has been struck between the darker tones of the bird's plumage and the delicate out of focus tones in the background. Whereas adjustments to brightness are applied equally across the image, increasing the contrast always starts from a tonal midpoint, so darker tones get darker and lighter tones get lighter, either side of that midpoint. So, while the bird could arguably be made darker by increasing the contrast, this would mean that the pale green and yellow tones would become unacceptably light. If this change in contrast were applied, followed by a reduction in brightness to bring the delicate background tones back to their original level, the bird itself would then become darker too, possibly more than would be acceptable. This is why separate highlight and shadow controls are sometimes far more useful than applying changes using brightness and contrast.

BALANCING BRIGHTNESS AND CONTRAST
A change to the contrast of an image often requires a subsequent adjustment to the brightness so, as with this delicate image, a compromise can be needed.

Focal length: 600mm, Aperture: f/11, Shutter speed: 1/500 sec., ISO: 5000

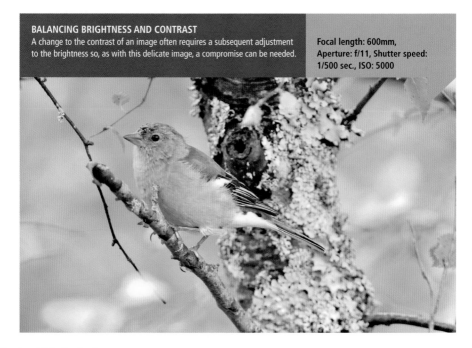

Hue

If your image-editing program offers hue adjustment it will radically shift color values, usually on a plus/minus scale. Negative values will make reds more purple, blues more green, and greens more yellow, while positive values will make reds more yellow, greens more blue, and blues more purple.

In these three images, the uppermost shows the image as it was recorded by the camera, the central image shows the maximum negative hue adjustment, and the lower image the maximum positive hue. These are extreme differences, selected for use here because subtle changes are sometimes hard to see when images are reproduced at this scale.

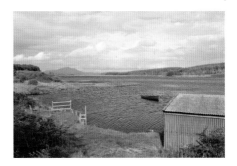

It is worth noting that the extent of the changes in different colors isn't equal. The most obvious change occurs in the red boathouse, which changes color completely in both of the lower images. However, the grass in the foreground doesn't change as dramatically, and it certainly doesn't turn completely blue in the lower image, as the green boat has.

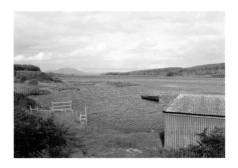

Similarly, in the lower image, the conifer trees on the far shore do not change a great deal, regardless of the hue adjustment made. If you do a lot of landscape photography, there is a lesson here: while we tend to think of grass and foliage as green, it is rarely a "pure" green and often contains strong elements of blue (for example, the conifers), yellow (rough grassland), and even red (the first two weeks of new leaves on broad-leaved trees).

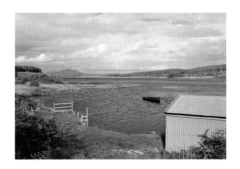

Shadow and highlight adjustment

These are two controls that the author finds extremely valuable in post-processing. Photoshop, as well as Nikon's Capture NX2 software, allows these adjustments to be made to both TIFF and JPEG files, while Canon's Digital Photo Professional software also provides this facility for RAW images. It would be helpful to be able to perform these adjustments prior to shooting the image, but at present only Canon's Highlight Tone Priority feature comes close and, even then, only subtle adjustments apply to the top half of the dynamic range.

The advantage of being able to adjust highlights and shadows independently is far more useful than a simple brightness control. If we examine the image below, which represents a typical problem, we can see immediately that the dynamic range presented by the scene is just too great to be captured perfectly in-camera.

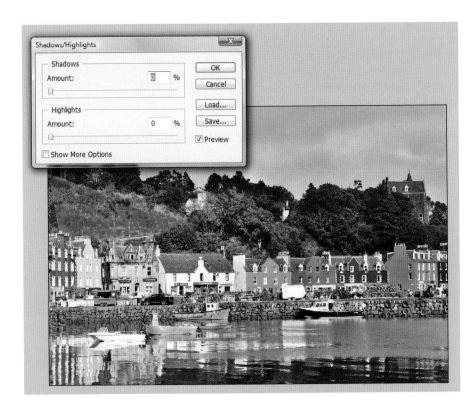

The darkest areas of the scene are among the trees and don't present too much of a problem, but the small white craft in the harbor, to the left of the image, is a major issue. The brilliant sunshine was welcome with regard to the rest of the subject matter, but this relatively small area of bright white is a different issue. By darkening the highlights slightly (which affects little else in this particular image), the white craft and its reflection can be made more manageable without any adverse effect on the image as a whole.

If your software doesn't provide you with these adjustments, there are still options open to you. Firstly, you could underexpose the whole scene then raise the overall level of brightness to the point where the white craft is bordering on unacceptable. This is not ideal, and you may generate unwelcome noise in the shadow areas, but it is a workable solution.

Alternatively, you could use an in-camera light-balancing mode if your camera has that option; Nikon's Active D-Lighting, for example.

You could also crop the original image—especially if the problem lies close to the side and/or bottom of the photo—and still be left with an attractive scene. This is worth remembering: if you think that part of the scene may be problematic in the final image, don't take every shot with that element in the center of the frame. Instead, vary its position to provide yourself with multiple cropping options.

You could also shoot the scene from different angles, in an attempt to exclude the troublesome part. This could, and arguably

should, include vertically oriented images, as I have done here. The one thing you should not do when faced with a scene as attractive as this, with perfect lighting, is just shoot a single photograph before moving on.

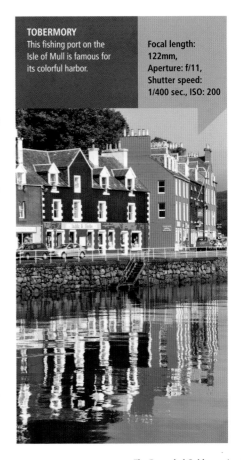

TOBERMORY
This fishing port on the Isle of Mull is famous for its colorful harbor.

Focal length:
122mm,
Aperture: f/11,
Shutter speed:
1/400 sec., ISO: 200

Levels

Another adjustment that cannot be carried out in-camera (at least at the time of writing) is levels. A levels adjustment is a way of changing the tonal range and color balance of an image using image-editing software to alter the intensity of the shadows, midtones, and highlights. This can be applied to the image as a whole, or to any one of the three color channels—red, green, or blue—that create a color image. If the latter are adjusted then this will alter the color balance also.

The first comments here apply to the Input Levels and histogram. The three key points of adjustment are the black point, gray point

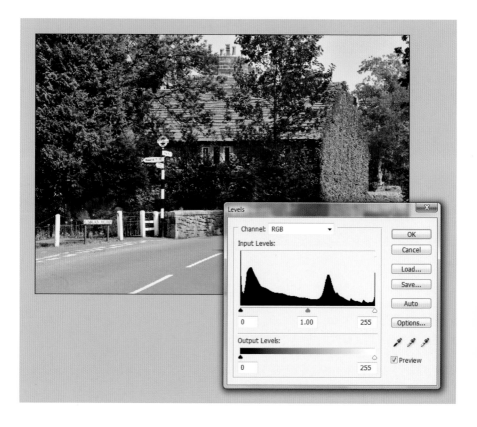

(midtone), and white point. Each of these has a numerical value—black (0), gray (128*), and white (255)—with a histogram illustrating the spread of tones in the image.

When an image does not include a full range of tones from black to white (0–255), the right and/or left edges of the histogram will not reach the edges of the graph. In these circumstances, a full range of tones can be achieved by dragging the black point slider and/or the white point slider to the end of the histogram, although you need to be careful not to clip the shadows and/or highlights when doing this.

Moving the midtone slider to the right will stretch the darker tones to its left while compressing the lighter tones to its right, and vice versa if it's moved to the left.

The same basic principles relate to color balance adjustments using the red, green, or blue channels (selectable from the Channel dropdown menu that shows RGB in the image opposite). If the original image has a distinct color cast, then moving the black or white point sliders will probably deliver a correctly balanced result. However, if all that is required is a subtle shift within an image that is, to all intents and purposes, perfectly good as it is, then minor

Note

The use of the eyedroppers, also seen in the image opposite, raises issues that are beyond the scope of this brief introduction to levels adjustment.

adjustment of the midtone slider would be a better option.

Moving the sliders for the Output Levels, restricted to just black and white points, will have the opposite effect to moving the Input sliders above them, so moving the black Output slider to the right will lighten the darkest tones (a quick way of decreasing contrast), while moving the white Output slider to the left will lower the brighter tones in the image. This is similar to using the shadow and highlight adjustment, albeit with less control.

If all of the above sounds too technical, the best way forward is to open an image and simply try these adjustments for yourself. The great thing with levels is that the changes are "live," so the image will change before your eyes. And you can always click on Cancel.

*The midtone value is only 128 when the full range of 0–255 is evident. However, this may not be the case, so the midtone will be shown initially as 1.00 to avoid confusion, changing to values greater or lower than 1.00 when moved.

White Balance Correction

Some cameras offer the ability to fine-tune the white balance, in much the same way as film users have relied on color-correction filters. The mechanism for doing this will obviously vary from one manufacturer to another, and Canon's system is illustrated here simply to give some idea of the possibilities.

The starting point is a graphic shown on the camera's LCD screen, divided into four quadrants. Before making any changes, the white cursor will be positioned at the center of these four quadrants: shifts to the left will increase blue, to the right amber, upward green, and downward magenta. In the example

below left, the white balance has been shifted a combination of three increments toward amber, and five increments toward green, with the shift shown at the right of the screen as Shift A3, G5.

If white balance bracketing is available, the single cursor will be represented by three evenly spaced cursors. In the example below, the degree of bracketing is shown to the right of the screen as being ±2 increments. Each increment in Canon's system is equivalent to five "mireds," a mired being a unit of measurement that indicates the density of a color temperature conversion filter.

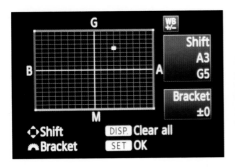

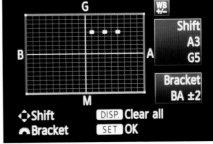

Curves

Adjusting the curves is yet another option available in post-processing for changing the color balance in an image. As with levels, this is a "live" process, with the image changing as you make the adjustment. You can select RGB to change the whole image, or you can select the red, green, or blue channel from the dropdown menu to make changes to the individual color channels.

In the example below, the green channel has been selected, but no change has yet been made, shown by the straight line running through the histogram from bottom left to top right. To change the tone curve, click on the line and drag it into a new shape. The outcome will vary depending on where you click along the line, and the direction and extent to which you drag that point. The exercise can be repeated using numerous points along the line. For the novice, tutorials and hands-on experience are the best ways to learn about what is possibly one of image-editing's most powerful tools.

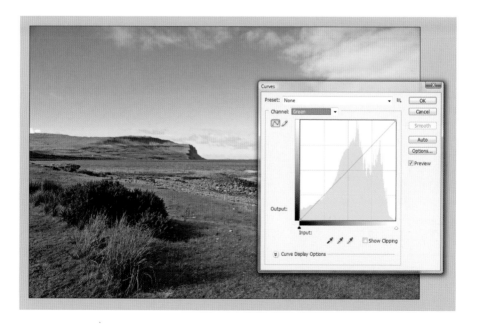

What went wrong?

Here we examine several images that display commonly encountered problems.

Highlights blown

ASSESSMENT
The image suffers from noticeable lack of detail in the white brickwork, causing the highlights to "burn out" and spoil an otherwise attractive photo. However, a darker exposure would have caused the colorful elements of the image to be too dark.

Focal length: 50mm, Aperture: f/8
Shutter speed: 1/750 sec., ISO: 200

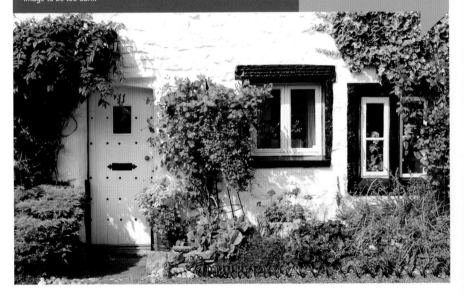

Solution

This is a situation where in-camera adjustments such as Canon's Highlight Tone Priority setting can be really useful.

Alternative solution

Canon's Auto Lighting Optimizer or Nikon's Active D-Lighting settings—both of which offer differing levels of control—would help balance the highlight and shadow areas and reduce the overall dynamic range. Lowering the contrast could also reduce the dynamic range.

RESCUE THE ORIGINAL IMAGE

The number of options during post-processing would be increased if working with a RAW image. Both Canon's Auto Lighting Optimizer and Nikon's Active D-Lighting settings could be applied in Digital Photo Professional or Capture NX2, respectively. However, a great deal can still be done with a JPEG image using the highlight/shadow controls in either of these programs or in image-editing software such as Photoshop.

Colors too vivid

ASSESSMENT

The majority of digital cameras have a "vivid" picture style, but this will often deliver abnormally strong colors, especially if a separate saturation setting is also increased. Any vivid mode should be used sparingly in selective circumstances, usually in low-light situations or scenarios where there is virtually no color at all except for a small part of the subject.

Focal length: 50mm, Aperture: f/8,
Shutter speed: 1/750 sec., ISO: 200

Solution

Have a set of camera settings that will serve you well in most circumstances, so that moving away from these settings is unusual. This will help you to focus on the task at hand and whether or not a setting warrants adjustment. It will also help you to remember to change the settings back to the norm afterward: if you are always changing your camera settings, you are bound to get into a muddle.

Alternative solution

A slight increase in saturation and contrast will usually suffice. These changes are also among the easiest to reverse (or increase) during post-processing, even if the image was recorded as a JPEG.

Changing the picture style from a vivid setting is likely to be possible if you shoot RAW images and are using the camera manufacturer's own software for your post-processing. Otherwise you will have to depend on reducing the saturation in an image-editing program, but this will almost certainly suffice.

Saturation too weak

Focal length: 35mm, Aperture: f/11, Shutter speed: 1/500 sec., ISO: 200

Solution

Adjust the in-camera saturation by either modifying or changing the picture style. For example, you could switch from Neutral to Landscape to increase the intensity of the greens and blues.

Rescue the original image

If the image was captured as a RAW file, Nikon's Capture NX2 software and Canon's Digital Photo Professional software can be used to apply an alternative (more saturated) Picture Control or Picture Style. With a JPEG image, increasing the saturation in an image-editing program would suffice.

Lighting balance needed

ASSESSMENT

If this boat was meant to have been captured within the context of its surroundings—Loch Katrine in Scotland's Loch Lomond and The Trossachs National Park—then those surroundings need to be clearer in terms of detail and color. Increasing the exposure of the image as a whole would not be an option, as the boat would burn out; it is already a touch brighter than is ideal.

Focal length: 82mm,
Aperture: f/5.6, Shutter speed:
1/500 sec., ISO: 100

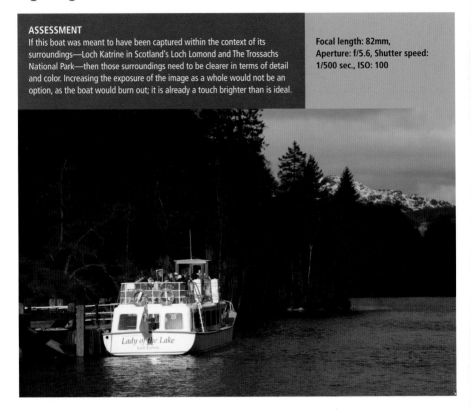

Solution

The strongest in-camera setting for Canon's Auto Lighting Optimizer, Nikon's Active D-Lighting, Sony's D-Range Optimizer, or any other manufacturer's equivalent would go some way toward solving the problem, although additional post-processing work would also be necessary.

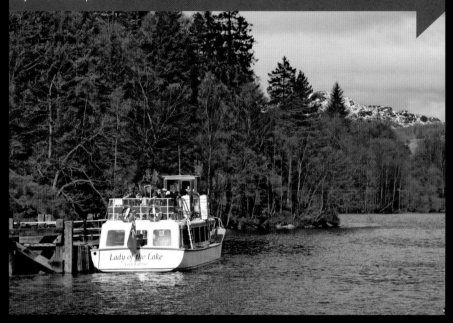

This example is a clear indication of the benefits of shooting RAW files. Post-processing adjustments can be applied with much greater control and flexibility, with the option of applying them to different parts of an image in differing degrees. This means that improving your post-processing skills should be considered almost as important as improving your photographic technique.

Experimentation

The two greatest advantages of digital photography are its reduced running costs and the ability to experiment—and the latter seems an appropriate topic on which to end this guide.

At one time, for example, the author used to shoot black-and-white infrared film for fun. At first it was usually a matter of trial and error, never being sure what the final result would look like until the film was developed. Now it is possible to use software to dial in the simulated effects of various different infrared films and to fine-tune the result.

The RAW image top left was captured in color and converted to black and white (top right) with only minor adjustments to the dynamic range. The grayscale version was then converted to infrared using Alien Skin's Exposure 3 software, with just a short sequence of mouse clicks creating an evocative image that is totally different to the original. But the real trick is the ability to view the original scene and recognize the opportunities it presents.

It also helps if you shoot your original images as RAW files. A RAW image allows an infinite variety of experiments to be performed on it, whereas a JPEG offers limited scope for adjustment. More importantly, the original RAW file will always be retained, no matter how many different permutations are saved. Even if the original RAW file is accidentally saved after making your experimental adjustments, it will always be possible to change the parameters

back to their original settings as these are memorized alongside the file.

However, in these days of rapid technological advancement, it is all too easy to get drawn into the maelstrom of argument about new camera features and image quality—or "pixel peeping" as it is often called.

This guide was written shortly after the author visited an exhibition by the legendary Don McCullin, who came to the fore with his images of the Vietnam conflict. His huge prints came from negatives that were shot in arduous conditions on battered cameras that lacked all but the most basic features, documenting historic events as they played out through the lives of ordinary people. Image quality was the last thing any visitor to the exhibition had in mind when they left. Instead they were filled with the sheer power of the subject matter and its treatment—and that, ultimately, is what great photography is really all about, regardless of the technology behind it.

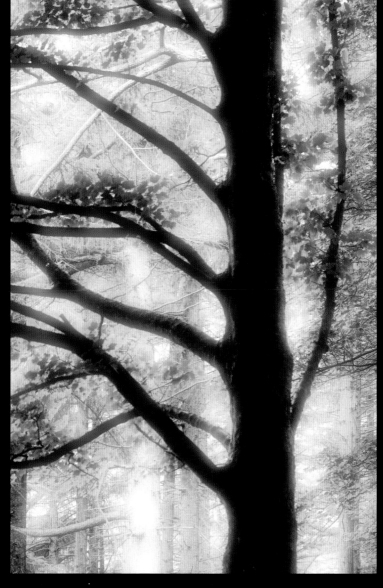

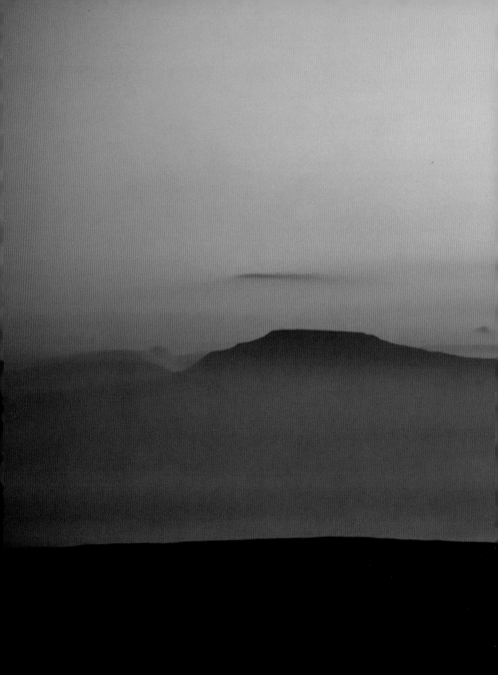

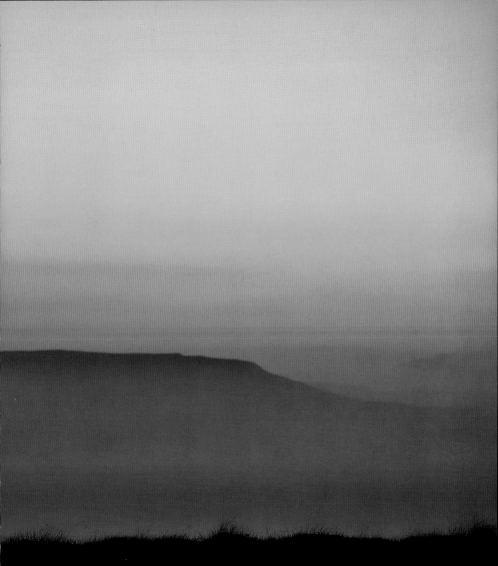

Glossary

Aberration
An imperfection in the image, often caused by the optics of a lens.

AEB (auto exposure bracketing)
A camera function that captures a predetermined number of images (commonly three, but also five, seven, or nine) at different exposure settings, usually straddling the meter's nominally correct settings. The increment (difference) between each exposure can be adjusted.

AE (auto exposure) lock
A camera function that locks the exposure value according to the scene in the viewfinder, allowing the user to adopt these settings for a different scene.

Ambient light
The natural light prevailing at the time of shooting.

Angle of view
The area of a scene that a lens takes in, measured in degrees.

Aperture priority
An exposure mode in which the user sets the aperture while the camera adjusts the shutter speed to suit the light conditions and selected ISO setting.

Aperture
The opening in a camera lens through which light passes to expose the sensor or film. The relative sizes of the aperture are denoted by f/stops.

Artificial light
A man-made lightsource such as a flash or continuous tungsten lighting.

Autofocus (AF)
A focusing system in which the lens is focused by electronic and mechanical means, without the user having to rotate the focusing ring.

Bokeh
A commonly used non-technical term to describe the out of focus background of an image.

Bracketing
Taking a series of images of the exact same scene, adding under- and overexposed images to the nominally correct exposure settings.

Buffer
The built-in memory of a digital camera, used as an intermediate step before images are downloaded to the memory card.

Burst size
The maximum number of frames that a digital camera can shoot before its buffer becomes full.

Centerweighted average metering
A light-metering pattern that measures the whole scene, but gives added bias to a substantial area in the center of the frame (as this is often where the main subject is positioned).

Chromatic aberration (CA)
The inability of a lens to bring spectrum colors into focus at a single point.

Circle of confusion
The size of an area of the image at which light rays cease to focus to a point and instead come together as a small circle. In human terms, this is the largest area that our eyes still perceive as a point.

Clipping
The loss of detail in highlights or shadows.

Color saturation
The depth of intensity of colors in an image.

Color space
Computers, cameras, and printing systems identify and interpret color information, known as color space, according to various systems—typically sRGB or Adobe RGB (Red, Green, Blue). Commercial printing uses the CMYK color space (Cyan, Magenta, and Yellow, with K representing black).

Color temperature
The color of a lightsource measured in degrees Kelvin (K).

Composition
The way in which elements of a scene are arranged within the image.

Compression
The process by which digital files are reduced in size.

Contrast
The difference in brightness between the highlight and shadow areas of an image, or a marked difference in illumination between colors or adjacent areas.

Crop factor
The number by which the field of view of a full-frame lens must be divided when used on a camera with a sensor smaller than 24 x 36mm (full-frame), because the maximum area of the image projected by the lens is not covered by the smaller sensor.

Cropping
The act of reducing the area of the recorded image.

Depth of field (DoF)
The zone within an image, both in front of and behind the subject focused upon, that appears in acceptably sharp focus.

Diffraction
The loss of image resolution when a very small aperture setting is used.

Dynamic range
The full range of shadows, midtones, and highlights that can record detail in an image.

Evaluative metering
A metering pattern in which a light reading is made from multiple zones across the subject area, usually encompassing the entire frame. Also known as matrix metering.

Exposure bracketing (see AEB and Bracketing)

Exposure compensation
A camera function that allows intentional over- or underexposure relative to the meter's suggested light-reading.

Exposure
The combined duration and quantity of light allowed through to the sensor or film, controlled by the aperture, shutter speed, and ISO settings.

Exposure Value
A numerical system for measuring the intensity of light, typically in the range 0–20.

f/stop
A number assigned to a particular lens aperture based on its relationship to the focal length. Wide apertures are denoted by lower numbers, such as f/1.8, and small apertures by larger numbers such as f/22.

Filter

A piece of colored (or coated) glass or plastic that is placed in front of the lens to achieve a particular effect, such as polarizing the light.

Focal length

The distance, usually expressed in millimeters, from the optical center of a lens to its focal point. Used in lens designations as an indicator of the angle of view: the greater the number, the narrower the arc covered by the lens.

Focus

The act of adjusting the lens, manually or using autofocus, so that the subject appears sharp.

Full frame

A term used to denote a digital camera that has a sensor with the same area as the negative of a 35mm film camera, i.e. 24 x 36mm.

High Dynamic Range (HDR) software

Computer software applications that allow the user to combine several versions of an image, each taken at a different exposure setting, to equalize the tonal range. This is the best way of dealing with subjects that have a tonal range exceeding the normal range that can be captured by the sensor.

Highlights

The brightest tones in an image.

Histogram

A graph used to represent the distribution of tones in an image.

Hyperfocal distance

The closest point of focus at which infinity falls within the depth of field. This is the point on which to focus to ensure that everything from that point to infinity is in focus, along with a significant zone in front of it.

Image stabilization

A mechanism built into either a lens or a camera that senses and reduces camera shake, typically providing an effect equal to using a shutter speed between 2 and 5 stops faster.

Incident light

The light falling on the subject, measured for the purpose of metering by facing the camera from the subject's position.

Increment

The difference between exposure settings, typically in ⅓, ½, or whole stops.

ISO (International Organization for Standardization)

The measurement of sensitivity of film or digital camera sensor settings is controlled by this organization to ensure compatibility across the imaging industry.

JPEG (Joint Photographic Experts Group)

A universal file format supported by all imaging software applications. JPEG files are compressed digital files, the degree of compression affecting image quality.

Macro

A term used to describe close focusing and the close-focusing ability of a lens. Strictly speaking, a 1:1 image ratio where the subject is recorded at its actual size.

Manual exposure

An exposure mode in which the user selects both the aperture and shutter speed independently.

Memory card

A removable storage device for digital cameras, commonly CompactFlash or SD/SDHC.

Metering

Using either the camera's built-in meter or a separate handheld lightmeter to measure the ambient (or flash) light in order to determine the exposure. Different in-camera metering patterns measure different areas of the scene.

Metering pattern *(see Centerweighted average, Evaluative, Partial, and Spot metering)*

Midtone

A tone that is half way between the deepest shadow and the brightest highlight.

Native ISO

The "normal" range of ISO settings that are provided by the camera. Many cameras also feature "expanded" ISO settings at either end of the range.

Noise

Image artifacts caused by failure of some pixels to adequately record image data. Can be divided into luminance noise (which looks similar to film grain) and chrominance noise, which manifests as inappropriately colored pixels.

Overexposure

The act of exposing the film or sensor to too much light, rendering the image far brighter than it should be and causing highlights to burn out.

Partial metering

A reflected light-metering pattern that measures a relatively small area at the center of the frame, but not as small an area as with spot metering.

Pixel

The smallest bit of information in a digital image. One million pixels equals one megapixel. The number of megapixels offered by a camera isn't the only guide to image quality, as the size of each pixel also affects quality.

Post-processing

The term commonly used to describe the manipulation of images on a computer.

Program mode

An exposure mode in which the camera automatically selects a combination of both aperture and shutter speed, but allows the user to change this combination without changing the overall exposure.

Program shift

The term sometimes used for the process of changing the combination of aperture and shutter speed in Program mode.

RAW

A generic term for an image file format in which the raw data from the sensor is stored without permanent alteration being made. Camera manufacturers tend to have their own RAW format, each with a different file extension (.CR2 for Canon, .NEF for Nikon for example). RAW files must be converted to a universally accepted file type such as TIFF or JPEG to be displayed and manipulated in some software applications.

Reflected light

The light reflected by the scene being photographed, for the purpose of metering.

Resolution

The number of pixels used to capture or display an image. The higher the resolution, the finer the detail.

Rule of thirds

A general compositional rule that places the key elements of a picture at points along imagined lines that divide the frame into thirds.

Scene modes
Camera modes designed to simplify the setting procedure for the user by naming each scene mode with the purpose for which it is intended (for example, Portrait, Landscape, Sports, Close-up) and automatically selecting the settings.

Shutter priority
An exposure mode in which the user sets the shutter speed and the camera adjusts the aperture to suit the light conditions and selected ISO setting.

Shutter speed
The setting which determines the amount of time that light is permitted to reach the film or sensor, usually measured in fractions of a second, but also in whole seconds or even minutes.

Shutter
A mechanism that controls the amount of time that light is allowed to reach the sensor.

SLR (single lens reflex)
A type of camera construction that allows the user to view the scene directly through the lens, using a reflex mirror.

Spot metering
A reflected light metering system that measures a very small portion of the scene.

Stop
A single EV (Exposure Value) step. Differs from f/stop as it applies to the shutter speed and ISO, as well as the aperture.

Teleconverter
A lens that is inserted between the camera body and main lens, increasing the effective focal length.

Telephoto lens
A lens with a long focal length and a narrow angle of view.

TIFF (Tagged Image File Format)
A universal file format supported by most imaging software applications. A TIFF is an uncompressed digital file format.

TTL (through the lens) metering
A metering system built into the camera that measures light passing through the lens at the time of shooting. Has the advantage of taking the affect of any lens-mounted filters into account when making the exposure reading.

Underexposure
The act of exposing the film or sensor to less light than is required, rendering the image far darker than it should be and potentially causing shadow areas to lose detail.

Vignetting
The darkening of the corners of an image, often caused by using a small aperture setting with several filters or the incorrect lens hood.

White balance
A camera function that allows the correct color balance to be set for any given lighting situation.

White balance bracketing
A camera function that captures several versions of an image, each with a slightly different white balance setting.

Wideangle lens
A lens with a short focal length and a wide angle of view.

Useful web sites

News and Rumors
www.1001noisycameras.com
www.canonrumors.com
www.dpreview.com
www.ephotozine.com
www.photorumors.com
www.nikonrumors.com
www.photographybay.com

Technique and Technical
www.digitalphotopro.com
www.sphoto.com
www.northlight-images.co.uk
www.luminous-landscape.com
www.outbackphoto.com
www.dxomark.com
www.clarkvision.com

Hyperfocal distance and Depth of field
www.cambridgeincolour.com/tutorials
www.dofmaster.com

Software
Adobe www.adobe.com
Alien Skin www.alienskin.com
ddisoftware www.ddisoftware.com
DxO www.dxo.com
FDRTools www.fdrtools.com
NIK Software www.niksoftware.com
PaintShop Photo Pro www.corel.com
Photomatix Pro www.hdrsoft.com
Tiffen www.tiffen.com/dfx_essentials
Toast Titanium www.roxio.com

Filters
www.leefilters.com
www.tiffen.com
www.cokin.com
www.formatt.co.uk
www.hoya-online.co.uk

Photography books and magazines
www.ammonitepress.com
www.pipress.com
www.thegmcgroup.com
www.eos-magazine.com

Retailers
www.acecam.com/chains.html
www.camerapricebuster.co.uk
www.adorama.com
www.ritzcamera.com
www.bhphotovideo.com
www.calumetphoto.com
www.blackphoto.com
www.speedgraphic.co.uk
www.bristolcameras.co.uk
www.calumetphoto.co.uk
www.fotosense.co.uk
www.jacobsdigital.co.uk
www.mathersoflancashire.co.uk
www.provisualdirect.co.uk
www.warehouseexpress.com

Bureau of Freelance Photographers
www.thebfp.com

Index